D0558314

IMAGES
of America

LIFEGUARDS OF
SAN DIEGO COUNTY

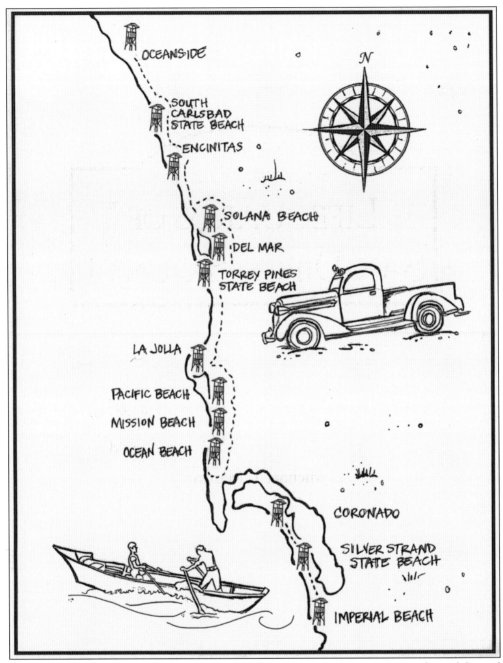

This map of the San Diego County coastline highlights the various city, county, and state lifeguard agencies from the United States' border with Mexico to Oceanside. (Courtesy of C. Martino.)

ON THE COVER: The 1965 San Diego County lifeguard staff poses in front of the county lifeguard headquarters in Solana Beach. Behind the lifeguards are the two rescue skiffs used for the myriad of aquatic duties that they performed off the coastline. (Courtesy of Tom Keck.)

IMAGES
of America

LIFEGUARDS OF
SAN DIEGO COUNTY

Michael T. Martino

ARCADIA
PUBLISHING

Published by Arcadia Publishing
Charleston SC, Chicago IL, Portsmouth NH, San Francisco CA

Printed in the United States of America

Library of Congress Catalog Card Number: 2007931273

For all general information contact Arcadia Publishing at:
Telephone 843-853-2070
Fax 843-853-0044
E-mail sales@arcadiapublishing.com
For customer service and orders:
Toll-Free 1-888-313-2665

Visit us on the Internet at www.arcadiapublishing.com

To all past, present, and future lifeguards
who keep their eyes on the water.

CONTENTS

ACKNOWLEDGMENTS

Thank you to my wife, Angie, who has supported yet another of my projects. Thank you to my brother for coming up huge with the coastal map. Thank you to my brother-in-law Ron and to Terry Xelowski for vehicle identification. Thank you to the lifeguard agencies from San Diego's south county to the north. Thanks to Capt. Robert Stabenow and the Imperial Beach lifeguards for responding to the border calls. Thanks to retired lifeguard supervisor Chuck Chase, whose able leadership I try to emulate in my current role at his old job. Thanks to Coronado lifeguard captain Sean Carey and retired lifeguard captain Russ Elwell. Sean, that new tower and headquarters will be built. Russ, the view of the bay from your porch is spectacular. Thank you to San Diego lifeguard lieutenant Nick Lerma for introducing me to Emil Sigler and for having more photographs than I could use in five books. Thank you to lifeguard Ed Vodrazka for the boxes of state park photographs. Thank you to Del Mar lifeguard sergeant Jim Lischer for having the foresight to preserve the documents when others were preparing them for the dustbin. Thank you to retired county lifeguard captain Jim Lathers, who watched beachgoers for over 30 years and, now that he is in his 80s, cruises the coast highway on his motorcycle. Thank you to Solana Beach lifeguard captain Craig Miller, who entrusted me with 60 years of lifeguard documents. Thanks to Encinitas lifeguard captain Larry Giles. Your service was born in the 1990s. May it live long and prosper. Thank you to all the state lifeguards who are keeping their eyes on the beaches in Carlsbad. Thank you to lifeguard sergeant Blake Faumuina and the Oceanside lifeguards. Thanks to photographer Tom Keck for your lifeguard photographs. Thank you to professor and lifeguard Arthur Verge for your help and for the George Freeth photographs. Thank you to my editor, Debbie Seracini, for the frantic dash to the finish. I also need to apologize to the lifeguards of North Island and Camp Pendleton. Time and tide kept me away from you, but in no way does this lessen the importance of your contributions to the lifeguard community. The story of lifeguards along our coastline is only beginning to be told.

INTRODUCTION

In a local history book like this one, the natural questions of "firsts" seem always to demand an answer. Who was the first lifeguard? When was his first day on the job? When and where did the first rescue occur? Who was the first female lifeguard? Who was the first to die in the line of duty? Unfortunately, in a county as large as San Diego, these answers are not easy to find. The first lifeguards were more like itinerant farmers than government employees. They worked for resorts or bathhouses. They traveled up and down the coast. They had work or did not have work based on the seasons, the weather, and the ocean conditions.

Eventually some lifeguards came from the ranks of the San Diego Police Department. Later they came from the County Lifeguard Service. Then lifeguards from the California State Parks showed up to guard the state beaches. Unincorporated areas incorporated, and beaches once patrolled by county lifeguards were patrolled by the newly formed city's lifeguards. In 1991, the City of Encinitas formed its lifeguard service. Now, instead of one group of lifeguards, there are nine distinct lifeguard services that cover the county's beaches from the border with Mexico to Camp Pendleton. Services are provided by the California State Parks (Silver Strand, Torrey Pines, San Elijo, and Carlsbad), the military lifeguards (North Island and Camp Pendleton), and the cities of Imperial Beach, Coronado, San Diego, Del Mar, Solana Beach, Encinitas, and Oceanside.

If you want to be picky, San Onofre State Beach is the real northern border of the San Diego County beaches, but the state park system includes it with beaches whose administrative center is in Orange County. The beach has, in a bureaucratic sense, migrated north, and its lifeguard history is not included in this work.

In the nearly 100 years that lifeguards have patrolled the San Diego County coastline, records of their exploits have gone from non-existent to Web sites that update statistics and even highlight interesting rescues. Unfortunately much of the early documentation is scattered or lost, and the pioneer lifeguards are no longer with us.

Lifeguards have a rich oral tradition, and stories of rescues and beach adventures are passed from old veterans to green rookies. Many agencies even cut newspaper clippings of rescue stories. These clippings are generally stuffed in an old box. Occasionally they are put in a folder or envelope; even less occasionally they make it into scrapbook. For some reason, the mementos frequently do not include the date of the event. The old stories intermingle and swirl like currents in a turbulent ocean. They move forcefully but refuse attempts at containment. General trends can be gauged, and some stories can be attached to particular decades, but, more times than I like to admit, I could not pin down a particular name or date to go with a story. I hope this lack of specificity does not discourage the reader interested in the history of San Diego County lifeguards. As difficult as some lifeguard stories are to associate with a particular lifeguard or date, others rise like beautiful, head-high waves that break spectacularly along the beach.

My search for "firsts" and my exploration of the history of San Diego County lifeguards brought me to times when the word lifeguard did not yet exist, though the concept was fully realized.

The men who watched the shorelines on both the east and west coasts of the United States were called coast watchers, life savers, or surfmen. They lived in buildings strategically placed along the shoreline. The buildings frequently had high towers, where the men spent endless hours scanning the often-empty ocean. The men patrolled the beaches on foot or on horseback. When someone was in distress, they usually rowed a rescue boat to the victim. Sometimes, they braved the water, as Surfman Midgett did one day in the late 1890s, when, according to a U.S. Life-Saving Service log book, he "plunged into the water, fought his way through the pounding waves to the side of the hulk, seized one of the ropes, and pulled himself hand over hand to the deck." Midgett took a moment to catch his breath, then grabbed a sailor, threw the man over his shoulder, slid down the rope, swam the man through the surf, and brought him safely to shore. Midgett repeated the deed two more times, rescuing two remaining sailors. Those men were the last of 10 that Midgett rescued that day. Though he was called a surfman during his time, any modern reader would certainly identify Midgett as a lifeguard.

Hundreds of men served in the same role as Midgett for the U.S. Lifesaving Service, started by an act of the U.S. Congress in 1848. Yet these were not the first "lifeguards." Before the U.S. Lifesaving Service, there was the Massachusetts Humane Society. Not to be confused with the modern Humane Society, the Massachusetts group, made up of hearty surfmen, formed in 1785 with the goal of saving human lives. Still, they were not the first. Nor were the British, who had formed a group dedicated to helping shipwrecked mariners in 1774, or the Dutch, who began a similar endeavor in 1767.

The first lifeguard group was begun in the Yangtze River region of China in 1708. Its name translates to "Chinkiang Association for the Saving of Life." The Chinese developed manned lifesaving stations, used boats designed specifically for rescue work, and even supported their stations through the collection of taxes. The first lifeguards were not the stereotypical blond-haired, blue-eyed beach boys, but short, dark-haired men who cruised the shoreline in a junk.

Lifeguard and historian Arthur Verge writes that George Freeth is "considered the father of modern ocean lifesaving." Born on November 9, 1883, on the Hawaiian island of Oahu, Freeth came to the mainland in the summer of 1907. He was instrumental in the formation of lifeguard services at Santa Monica and Redondo Beaches. Freeth ventured south to San Diego County in 1915, when he accepted a position with the San Diego Rowing Club as a swim instructor. He supplemented his income by working as a lifeguard on Coronado Island in the summer.

But Freeth was not the first lifeguard to work the shores of San Diego County. In 1913, a lifeguard named John Brown responded to cries of help near Wonderland Point in Ocean Beach. Several swimmers were caught in a rip current that had pulled them away from shore. Brown attempted to throw the struggling swimmers his rescue can, but they could not reach it. Brown then tried swimming to the victims, but the surf and current caught him, and he struggled to stay afloat. Some men who had witnessed the commotion from shore came to Brown's aid and rescued five of the struggling swimmers. The rescuers lost two additional people to the current before finally dragging Brown to the beach. Sadly, it was too late for Brown, who had died of an apparent heart attack. Thus the question of who might be the first lifeguard in San Diego County to have died in the line of duty is answered by the name John Brown.

Before Brown, there was Louis Chavard, whose name appears as Chauvaud in newspaper accounts and as Chavard in a San Diego City Lifeguard scrapbook. Chavard was a lifeguard who worked for the San Diego City Police Department and was assigned to Ocean Beach. His employment can be traced back to the summer of 1906. Chavard and three other police lifeguards were involved in one of the most dramatic rescues and mass drownings in the history of San Diego County.

The surf was high and the weather was beautiful on Sunday, May 5, 1918. Newspaper accounts tell of "three lines of breakers" and "a crowd of over 5,000 holiday makers," a crowd almost completely made up of World War I servicemen who were attending a celebration sponsored by the Benbough Bath House. Lifeguard Louis Chavard had his hands full. He was working with

Frank B. Merritt, a motorcycle patrolman for the city police department. Merritt had been serving on the special lifeguard detail for a number of years due to his swimming and boat-handling abilities. Patrolmen Frank Gilroy and G. G. Freese rounded out the lifeguard crew for the day. Like Merritt, both men were assigned to the detail because of their skills in the ocean. The morning proceeded with few incidents other than the mundane tasks of advising swimmers of potential dangers and suggesting that they move to a safer bathing location.

As the day progressed, the tide began to fill in, and the surf continued to build. At 2:30 p.m., Chavard went to warn a group of 20 servicemen about the dangerous conditions and ask them to move closer to shore. The servicemen ignored the lifeguard and, according to Chavard's later testimony, laughed at him and swam further out. At this same time, large waves had pushed water up along the shore, and in the following lull, the water started rushing back to sea. Suddenly, bathers who had been no more than waist deep a moment before were swept out over their heads as the water headed back to sea, forming strong currents in the channels. The servicemen were swept away.

The lifeguards attempted to launch the rescue boats, but the large waves swamped them immediately. Undaunted, they righted the boats and made another attempt, only to be swamped again. Chavard swam after a group of people. Four men desperately clamored for him and grabbed him. Two men who Chavard believed to be Mexicans clutched his neck, while the others wrapped around his body. Chavard fought off the men who were grabbing his neck and struggled to bring the other two ashore. He ran back into the water and brought in a semi-conscious woman.

Servicemen who could swim were bringing in victims. A soldier named Hacklander brought in five people, while another named Newcomer swam out where no lines or boats could reach and saved a drowning man. A citizen identified by newspaper accounts as both Arthur Wilson and Alfred Wilson jettisoned his shoes but swam fully clothed out beyond the first set of breakers to bring in two victims. Wilson helped Merritt drag in the lifeless body of Hugh Burr before Merritt collapsed, unconscious. Wilson maintained consciousness, but was sapped of any strength for more rescue work. Two dead bodies, along with gasping and unconscious victims, practically littered the beach. When nearly two hours of intense and chaotic rescue work were over, 2 people were confirmed dead, 11 were missing and presumed dead, and over 60 had been rescued.

By Wednesday morning, May 8, the city councilmen convened to interview experts who could advise them on how to avoid such a tragedy in the future. The principal man they summoned was George Freeth, who, referring to his experience on the beaches of Los Angeles County, recommended increased staffing, an ambulance equipped with a resuscitator, and a motorcycle patrol for faster response times to critical incidents. The council adopted many of Freeth's suggestions, including the rescue motorcycle, and soon Freeth was patrolling the beaches of the south county.

Sadly the history of lifeguard services along the coastline of San Diego County is rooted in death. It is unfortunate that the noble and valuable work of lifesaving is seldom supported before a tragedy occurs. It seems it is only after a tragedy that formerly non-existent funding suddenly appears.

In 1940, it was not one single event but an accumulation of events that convinced a previously unsympathetic group of county supervisors to approve funding for a county lifeguard service. After having failed approval by one vote in 1940, the measure came back to the county supervisors in 1941. A Mrs. Penwarden, whose husband was a San Diego city lifeguard, had been an unsuccessful advocate for a county lifeguard service, but after nearly 40 drowning deaths occurred along the county beaches of San Diego in 1940, the supervisors approved $1,200 to start a new lifeguard service for the county beaches.

Exactly 23 years after the Ocean Beach tragedy, San Diego lifeguard captain Charles Hardy oversaw the civil service lifeguard exam for candidates trying out to become the county's first lifeguards. The candidates performed resuscitation drills, swimming rescue drills, and boat rescue

drills. Rough surf overturned one of the rescue dories and briefly trapped a lifeguard candidate under the overturned craft. A few tense moments later, the smiling would-be lifeguard crawled out from the overturned boat, unharmed.

When the May 5, 1941, tests were completed and the scores tabulated, longtime city lifeguard lieutenant William Rumsey earned the rank of number one with a score of 94.8. By May 20, newly appointed Captain Rumsey had $1,200 dollars and the county supervisors' edict to create a lifeguard service by June 1. Rumsey had the seed money, and now he needed the lifeguards.

San Diego County encompasses 73 miles of accessible oceanfront and 81 miles of bay-front shoreline and is patrolled by over 600 dedicated men and women. Through the years, these trained rescue professionals have guarded the county's beaches with the hope of keeping the unknowing, the unwary, and the just plain unlucky safe from the perils inherent in the open-water environment. Modern equipment has come into use, with personal watercraft replacing the old surf dories, wetsuits replacing woolen swimsuits, and flexible foam or hard plastic replacing the old tin cans, yet the mission of the modern lifeguard is still the same as that of early rescuers: to diligently watch the water and quickly respond to those in need.

One

IMPERIAL BEACH

Calling itself the "Most Southwesterly City in the USA," Imperial Beach incorporated as a city in 1956. From 1941 until its incorporation, the beaches of the south county were under the watchful eyes of the San Diego County Lifeguard Service. In June 1941, lifeguard Allan "Dempsey" Holder was among the first group of nine lifeguards appointed under Capt. William Rumsey. Holder, known to everyone as Dempsey, had camped along the local beaches when he and his family vacationed in the area years earlier. As a lifeguard, he became responsible for visitor safety on the beaches he loved. Holder became a Southern California surfing legend because of his knowledge and his experience surfing the Tijuana Sloughs, an area famous for its ability to hold large swells. The Tijuana Sloughs and Dempsey Holder were a must-see for anyone wanting to test their abilities in giant offshore surf. Holder earned the rank of lieutenant and was in charge of the county station at Imperial Beach. In 1956, when Imperial Beach became a city, Holder was appointed the director of the city's parks and recreation department, and he also oversaw the new city lifeguard operation. The new Imperial Beach lifeguard headquarters is named the Dempsey Holder Safety Center in his honor.

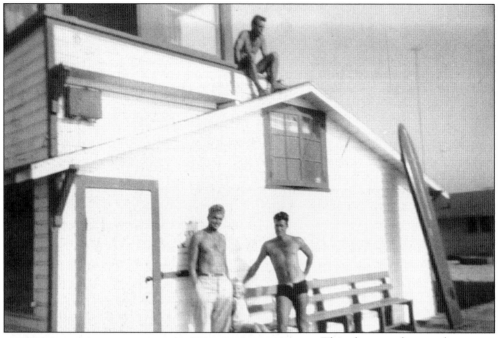

This photograph was taken
outside the county lifeguard
headquarters at Imperial Beach.
Pictured are Jim Lathers (atop
the tower, in his usual position
on the roof), Dempsey Holder
with daughter Elizabeth Ann
(Liz Ann), and Dick McCoy.
(Courtesy of Jim Lathers.)

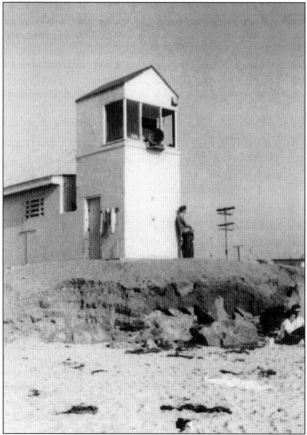

This is the Imperial Beach city
lifeguard tower, located off Palm
Avenue. Lifeguards used the
large speaker in the window
to warn swimmers and bathers
of dangerous conditions. They
entered and exited the building
via a steep ladder that reached
from the second floor to the first.
(Courtesy of City of Imperial
Beach Lifeguard Service.)

San Diego County lifeguard Jim Lathers keeps a watchful eye over the waters of Imperial Beach from the county's lifeguard headquarters building. The wooden railing that appears below Lathers outlines the boardwalk, made of 2-by-8-inch redwood planks, that ran along the beach. A winter storm in the third week of January 1953 destroyed the boardwalk, but concrete riprap saved the lifeguard station from destruction. (Courtesy of City of Imperial Beach Lifeguard Service.)

County lifeguard Jim Lathers assists Red Cross volunteer Evelyn Peritz in gathering another signature for the yearly Red Cross pledge drive. The caption accompanying the photograph reads, "And sometimes the girls are lucky, too." Throughout history, lifeguards have seldom been shy concerning the benefits of the job. (Courtesy of Jim Lathers.)

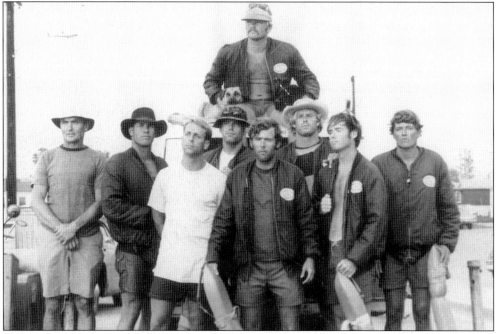

Never much for the formal attire of uniforms, the members of Dempsey Holder's 1967 crew pose here in their jackets; all of their other uniform items are attributed to individual taste. Pictured with an unidentified canine mascot are, from left to right, Capt. Dempsey Holder, Jim Barber, Jack Ogle, Ward Ogle, Richard Abrams, Don Davis, Chip Wilder, Jerry Ellis, and Shawn Holder with the pooch. (Courtesy of City of Imperial Beach Lifeguard Service.)

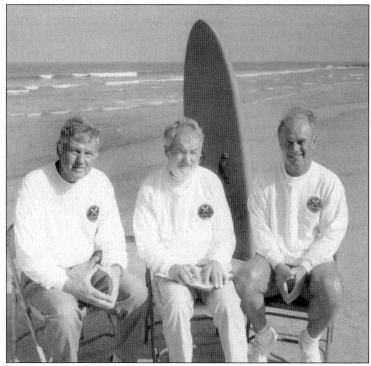

From left to right, Jim Voit, Dempsey Holder (former county lifeguard and Imperial Beach lifeguard captain), and Russ Elwell (former Imperial Beach lifeguard and Coronado City lifeguard captain) sit for a 1996 interview about Tijuana Sloughs and the old days of the lifeguard service. Holder died at his home on September 22, 1997. (Courtesy of City of Imperial Beach Lifeguard Service.)

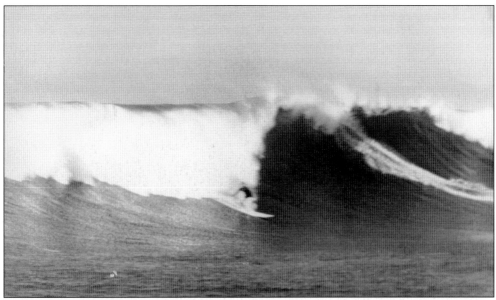

As a child, Dempsey Holder camped at the Tijuana Sloughs with his family. Drawn back to the location as an adult, he dedicated his life to saving those in need along the shores of Imperial Beach and to mastering the sloughs, one of the big-wave spots in Southern California. Holder and Bob Simmons shaped surfboards designed specifically for the waves at the sloughs. In this photograph, taken in the winter of 1975, 45-year-old Holder gets set up for a long ride to the right. (Courtesy of City of Solana Beach Lifeguard Service.)

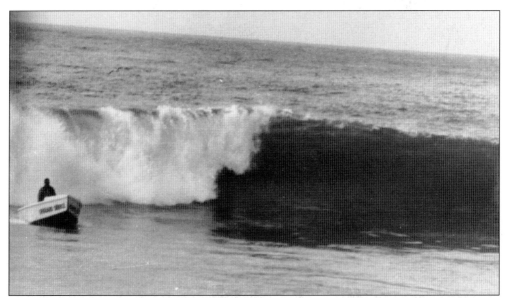

Dempsey Holder puts the lifeguard rescue skiff through the paces at Tijuana Sloughs. Lifeguards who worked with Holder say that he took every opportunity to get the boat out in all conditions. The bigger the surf and the rougher the conditions, the more he wanted to get out and practice with the boat. (Courtesy of City of Solana Beach Lifeguard Service.)

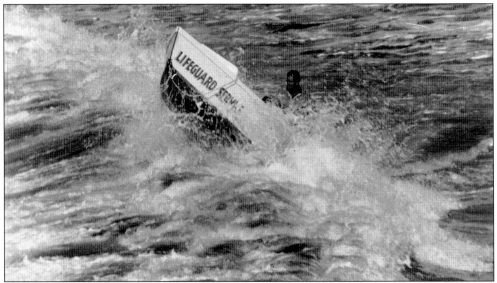

Dempsey Holder skillfully works his way through the surf. He made the boat dance on the water. (Courtesy of City of Solana Beach Lifeguard Service.)

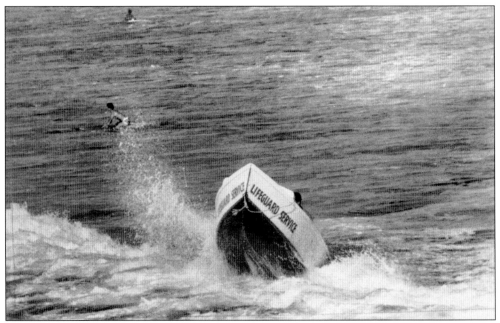

Holder did not shy away from finding a lifeguard who would take the boat out to the sloughs with him. If the lifeguard was willing to risk being pounded on the head by surf as Holder challenged the waves, the reward was a boat ride out to the lineup and a pickup on the inside for the return trip. (Courtesy of City of Solana Beach Lifeguard Service.)

The famous "White House" was the old county children's home before Holder lived in it. Located south of the main lifeguard headquarters, the building provided a crash pad for itinerant seasonal lifeguards and for the stray dogs that roamed the beaches of south county for years. One visiting Australian lifeguard exclaimed, "It's a flippin' surf house!" Old-time Imperial Beach lifeguards could not agree more. (Courtesy of City of Imperial Beach Lifeguard Service.)

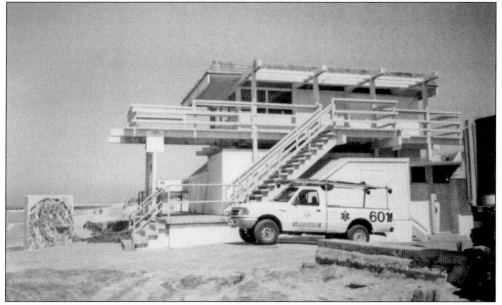

When the city of Imperial Beach incorporated in July 1956, county lifeguard lieutenant Dempsey Holder became the director of the city's parks and recreation department. Holder was instrumental in getting a new lifeguard headquarters building completed. The building stood until 1998, when ground was broken for the new safety center. (Courtesy of City of Imperial Beach Lifeguard Service.)

The Dempsey Holder Safety Center, named after the enigmatic leader of the Imperial Beach lifeguards, went under construction in 1999. The center was part of a San Diego Port District project to revitalize Imperial Beach's waterfront. In addition to serving as lifeguard headquarters, the building also contains a substation of the San Diego County Sheriff's Department. (Courtesy of City of Imperial Beach Lifeguard Service.)

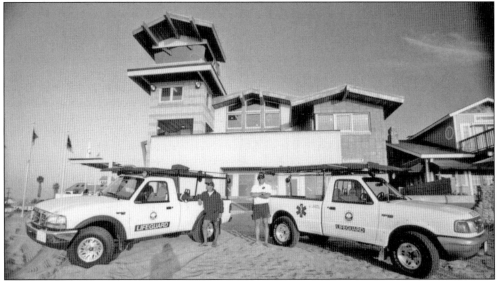

Two proud Imperial Beach lifeguards pose with their patrol trucks in front of the newly completed Dempsey Holder Safety Center. Lifeguard stations have come a long way from the poorly constructed, non-insulated, two-story towers of old, which utilized ladders to access upper floors. Today they are state-of-the-art buildings with elevators. (Courtesy of City of Imperial Beach Lifeguard Service.)

Two

STATE LIFEGUARDS

Imperial Beach may be the nation's most southwesterly city, but the lifeguards of the California State Parks are responsible for the most southwesterly beach in California, Border Field State Park. The lifeguards of the state park system cover the most widely dispersed geographical area of any lifeguard agency in the county. In addition to Border Field, beaches guarded by state lifeguards include Silver Strand, Torrey Pines, Cardiff, San Elijo, South Carlsbad, and Carlsbad State Beaches.

Robert J. Isenor was the first appointed permanent state park lifeguard. In June 1950, the former Newport City lifeguard started the California State Parks Lifeguard Service at Huntington Beach. By the mid-1950s, state lifeguards were providing lifeguard services at the above-named beaches, covering territory previously covered by the San Diego County lifeguards. This allowed county lifeguards to tighten their focus on beaches still under their control, but it also created a natural territorial rivalry. Though lifeguards always cooperated in any emergency, there were plenty of non-emergencies when the rivalry showed through. Most complaints centered on state guards' extended response times and lack of local control. Since state-run beaches were part of a statewide system, local beach communities often felt unrecognized by the bigger state system. Moonlight State Beach is a good example: it has been under county, state, and now local control.

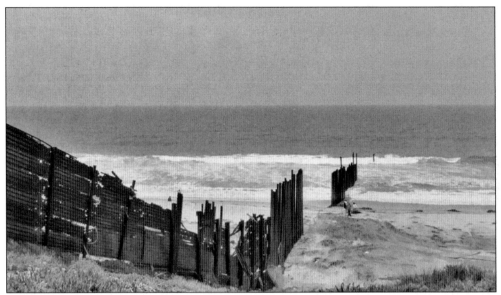

The fence (or lack thereof) at the border has been and will continue to be a controversial location. Lifeguard Greg Abbott recalls days of mariachi bands and a free exchange of goods and services between American and Mexican beachgoers. A strong rip current pulls from the Mexican side of the fence to the American side, and many Mexican beach patrons have been rescued by state lifeguards. Lack of funds and polluted waters have hampered state lifeguards' attempts at consistent patrols along the border beach. (Courtesy of California State Parks Lifeguard Service.)

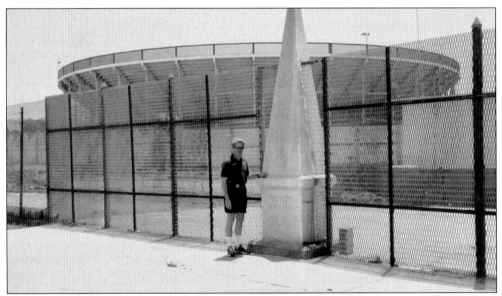

Alex Peabody, the California State Parks System's highest-ranking lifeguard, stands atop Monument Mesa. Peabody currently works in the position from which Isenor retired, overseeing lifeguard operations from as far south as the border to as far north as Sonoma County. (Courtesy of California State Parks Lifeguard Service.)

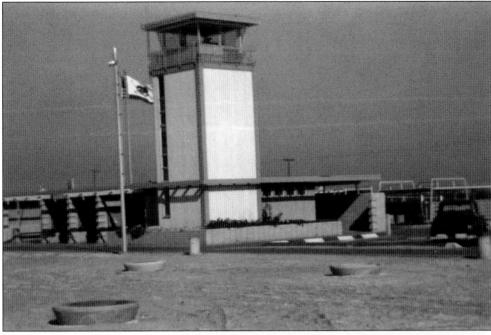

Though the identifying name of the department seems to change—it was known as the Division of Beaches and Parks, then as the Department of Parks and Recreation, and now as California State Parks—one thing has remained constant: the four-story lifeguard headquarters at Silver Strand State Beach. Built in 1960, the tower has remained virtually unchanged for 50 years, with only a slight remodel in the late 1980s. It still stands today. (Courtesy of California State Parks Lifeguard Service.)

Lifeguards improvised a knotted escape rope for the tower, which is four stories in height and is accessed by wooden and spiral staircases. Here, one of the guards practices his escape, not wanting to be the victim of a high-rise fire. (Courtesy of California State Parks Lifeguard Service.)

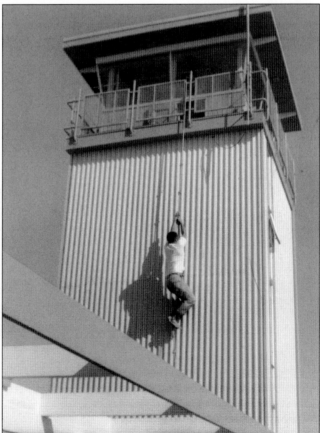

A friendly beach patron shows lifeguards that, while they have to work to keep the beaches safe, she gets to have twice the enjoyment that they do. But when the typical 10 a.m.–to–6 p.m. shift was over, many an eager lifeguard rushed to catch up on the fun. (Courtesy of California State Parks Lifeguard Service.)

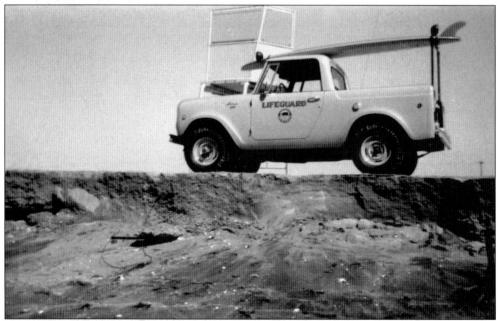

The 1968 International Harvester Scout patrol truck skirts a storm-created berm along Silver Strand State Beach. The portable tower behind the truck did not offer much protection from the elements, but it had the advantage of being easily moved if threatened by winter storms. (Courtesy of California State Parks Lifeguard Service.)

This is a closer view of the portable tower on a cloud-covered winter day. The front screen afforded minimal wind protection but offered no protection from the sun. With very little room to move, lifeguards were literally sentries on the beach. (Courtesy of California State Parks Lifeguard Service.)

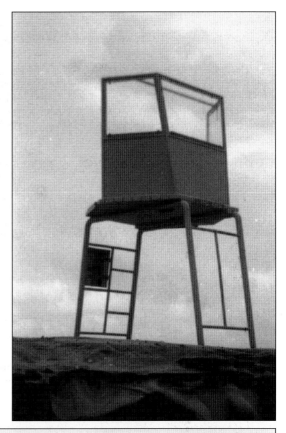

Pictured are the 1966 Silver Strand lifeguards with lifeguard supervisor Chuck Chase (bottom right). The lifeguards are identified by last name, with their nicknames in parenthesis. They are, from left to right, the following: (first row) Rombold (El Pete) and Chase (Dapper); (second row) Otis (Doc Old Man or Doc Otis), Campbell (Python), O'Hare (the Mini Thick), Abbott (God), Seldon (the Thick), Cosby (the Ferret), Gerry (G. I. Joe), Crawford (L. G. Trim), Bruce (Mr. America), and Lusky (Our Faithful Quarterback). (Courtesy of California State Parks Lifeguard Service.)

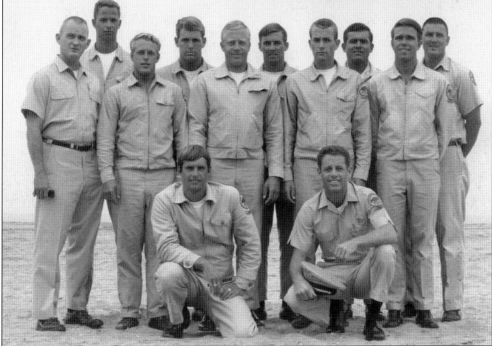

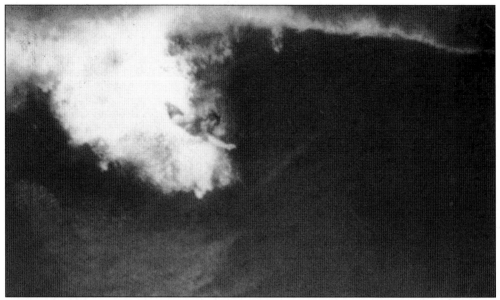

Silver Strand lifeguard Greg Abbott spent his time off keeping in shape and getting ready for the upcoming summer season. Here, he drops in at Pipeline in 1964. Like many lifeguards, Abbott dedicated his life to the ocean; he lived, worked, and played in it. Abbott has legendary status at the Strand and is honored with the title of lifeguard emeritus. (Courtesy of California State Parks Lifeguard Service.)

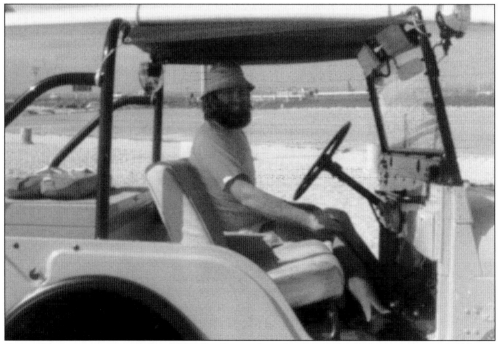

Greg Abbott is seen on patrol in 1975. This Jeep at least has a tarp for sun protection, and Abbott's full beard provides additional protection. Lifeguards of the past were admired for their tans, and it was not until the 1980s that lifeguards suffering from skin cancer brought the dangers of excessive sun exposure to the attention of the public. (Courtesy of California State Parks Lifeguard Service.)

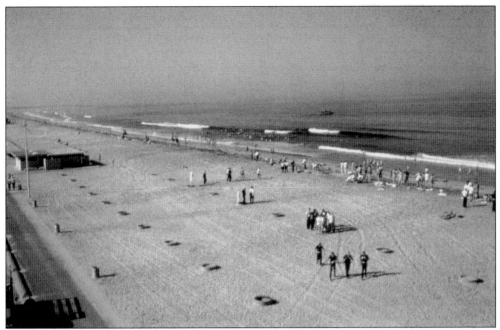

The Boy Scouts enjoy a jamboree on Silver Strand State Beach in 1961. Lifeguards in the tower and on the beach have an excellent view of the boys, and a vessel offshore provides extra eyes. The opportunity to help kids learn about the ocean while keeping them safe is one of the fringe benefits of the job. (Courtesy of California State Parks Lifeguard Service.)

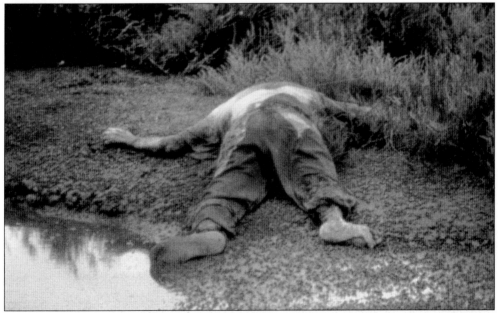

In addition to Silver Strand State Beach, the state lifeguards are responsible for Border Field State Park. The border fence did not exist in the past, and many emigrants from Latin America attempted to cross the border illegally at the ocean or through one of the many culverts running into the park. This image of the body of an unsuccessful 1970s border crosser illustrates one of the more unpleasant duties that a lifeguard must perform. (Courtesy of California State Parks Lifeguard Service.)

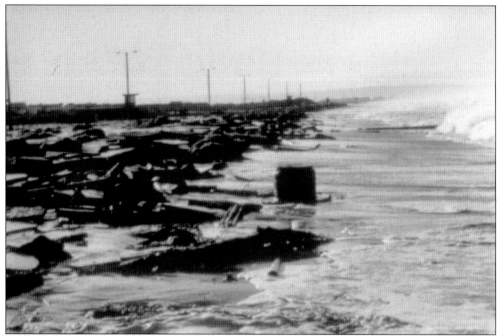

The El Niño year of 1983 punished the California Coastline. Silver Strand State Beach was not immune to the fury. In the photograph above, which looks south toward Mexico, the surf pounds the beach and parking lot. The portable lifeguard towers, which were set just far back enough into the parking lot, survived. The photograph below looks north at the parking lot. The main lifeguard tower was protected by a small cement-block wall, which had over 10 feet of sand stripped from its base during the storm. The damage from this storm provided an opportunity for a remodel a few years later. (Courtesy of California State Lifeguard Service.)

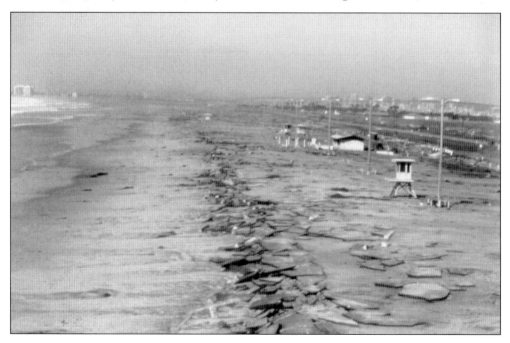

Lifeguard supervisor Chuck Chase is pictured in his office in the 1980s. Chase was in charge of the Silver Strand State Beach lifeguards from 1966 until his retirement in 1992. Much admired for his abilities in the water and on the beach, Chase is still fondly remembered by those who had the privilege to work for him throughout the years. (Courtesy of California State Parks Lifeguard Service.)

Lifeguard Supervisor Dave Price took over the operation at Silver Strand after Chase's retirement in 1992. Price, whose long career saw him working at Huntington Beach, San Clemente, San Diego Coast North Sector, and then the Silver Strand, retired in October 2004. (Courtesy of California State Parks Lifeguard Service.)

Lifeguard supervisors Mike Silvestri (left) and Mike Martino oversee a lifeguard requalification swim. State lifeguards must pass an annual 1,000-yard ocean swim in under 20 minutes. Returning lifeguards who do not qualify are not rehired for the new summer season. (Courtesy of California State Parks ranger Jon Irwin.)

Lifeguard emeritus Greg Abbott returns from his duty as paddler—the person who lifeguards for the lifeguards—for the requalification swim. Abbott worked the beaches of Border Field and Silver Strand for over 30 years. As of 2007, he still works part time as a resource ecologist for the California State Parks. (Courtesy of California State Parks ranger Jon Irwin.)

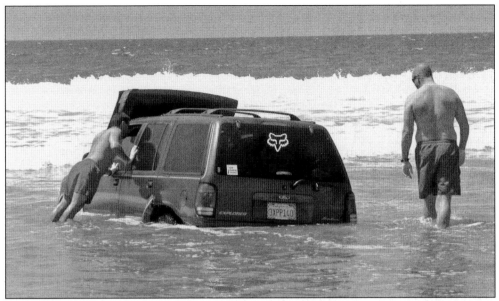

Lifeguards Guy Souza and Jason Lohrey make a cautious approach to a suspicious vehicle. They suspected a possible suicide, but, thankfully, the driver had just lost his way in a drunken stupor. State lifeguards, working with the military police, located the driver as he attempted to convince a tow truck driver that it would be acceptable to drive onto the beach to retrieve the truck. The MPs took the driver to jail and towed the truck off the beach with a bulldozer. (Courtesy of California State Parks ranger Jon Irwin.)

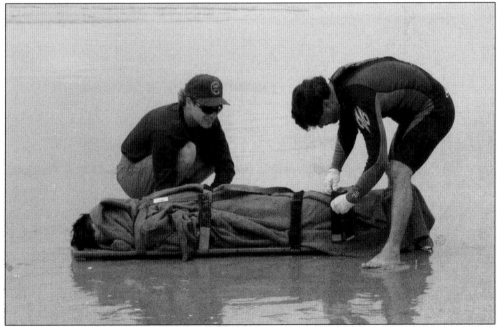

Lifeguards Sean Homer and Guy Souza complete a body recovery at Silver Strand State Beach. The teenaged boy had drowned off a Tijuana beach 10 days earlier, and it was Homer and Souza's luck to spot the body in the surf while they were on patrol on May 5, 2005. (Courtesy of California State Parks ranger Jon Irwin.)

The Torrey Pines Station was operated by the City of San Diego in the early 1950s. San Diego and the California State Parks have shared responsibility for certain parks over the years. (Courtesy of City of San Diego Lifeguard Service.)

Today Torrey Pines State Beach is one of the most popular beaches in the north county. Lifeguard Wade Frontiere keeps a watchful eye over the crowd on July 1, 2007. (Courtesy of lifeguard Ed Vodrazka.)

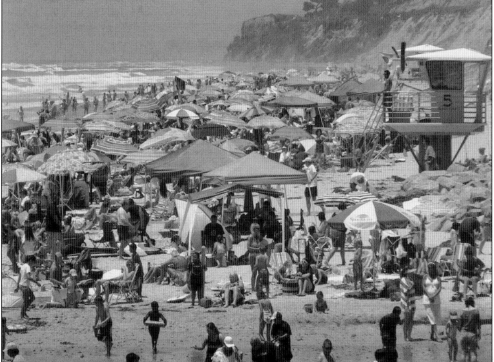

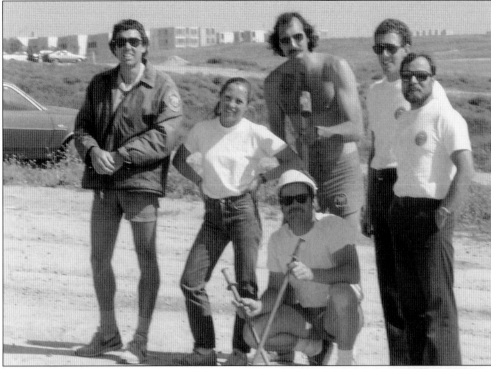

The bluffs above Torrey Pines and Blacks Beach provide plenty of opportunity for trouble. Hikers attempting to scramble up or down the cliffs often become stuck, and lifeguards are called to aid the climbers using cliff-rescue equipment. Ranger Greg Hackett and lifeguards Mary Bevins, Eric Smith, Jim Bilz, Denny Stoufer, and C. L. Price take a break from training in the early 1980s. (Courtesy of California State Parks Lifeguard Service.)

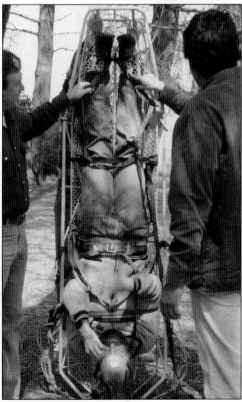

Cliff-rescue students Scot Lieziert and Leonard Ortiz show instructor Lou Marquette that they have mastered the basics of securing a victim in a Stokes basket. (Courtesy of California State Parks Lifeguard Service.)

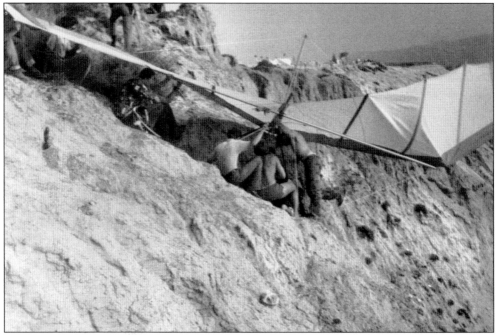

Hikers are not the only ones who have difficulty along the coastal bluffs. Errant hang gliders find ways to get stuck, too. (Courtesy of California State Parks Lifeguard Service.)

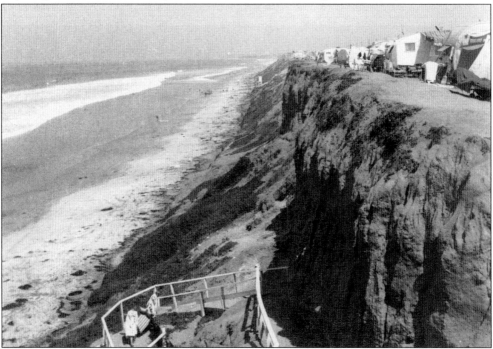

In the early days of camping at San Elijo State Beach, visitors came right up to the edge of the drop off. Coastal erosion and safety concerns led to the construction of a fence along the top of the bluff. Today's campers enjoy a similar view but are not allowed so close to the edge. (Courtesy of California State Parks Lifeguard Service.)

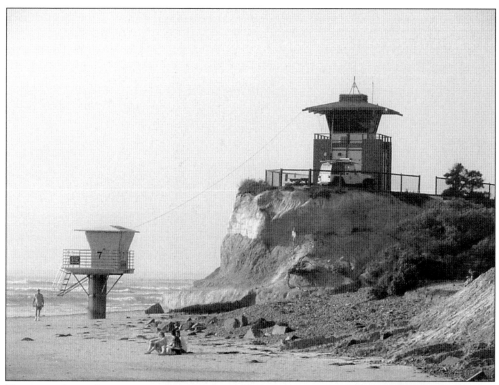

Having withstood tide and storm (not to mention coastal erosion) since the 1960s, the lifeguard headquarters at San Elijo State Beach is scheduled for replacement in 2008. (Courtesy of California State Parks Lifeguard Service.)

Timm Cook was a lifeguard supervisor for many years along the San Diego coast. He handled the various details associated with hiring and scheduling over 100 lifeguards each summer. Cook died of cancer in 1999. (Courtesy of California State Parks Lifeguard Service.)

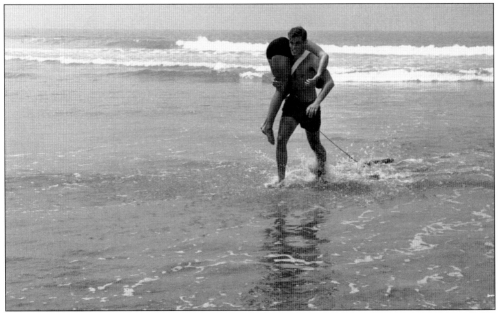

In 1966, an applicant brings his "victim" to shore while training in Carlsbad. Many of the lifeguard agencies at the time had a component of the test in which lifeguards needed to carry an unconscious victim from the water to a finish line on land. If the prospective lifeguard could not carry the victim, he failed the test. (Courtesy of California State Parks Lifeguard Service.)

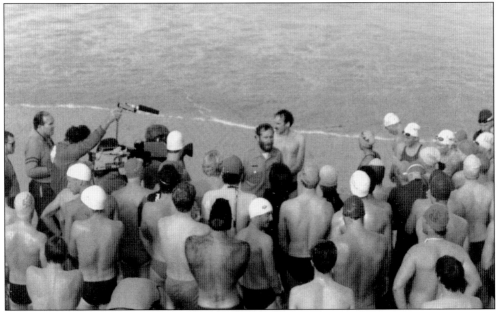

Lifeguard supervisor Mike Silvestri is surrounded by lifeguard applicants and members of the press. State park lifeguard candidates must pass a 1,000-yard ocean swim in under 20 minutes. After successful completion of that test, they compete in a 200-yard run, a 400-yard swim, and another 200-yard run, all of which must be completed in less than 10 minutes. Those who pass the physical are given an oral interview, and those who pass the interview are invited to the 80-hour lifeguard training at Huntington Beach. (Courtesy of California State Lifeguard Service.)

Three

CORONADO

The most distinguishing feature and major landmark in the city of Coronado is the Hotel del Coronado, which opened on February 1, 1888. The hotel and surrounding beach became a popular spot for those seeking relief from the summer heat. Other beach visitors rented tents from vendors and stayed along the beach for weeks in an encampment known as "Tent City." To help manage the crowds, part-time lifeguards were hired for the summer season.

George Freeth and Charley Wright were two of the earliest known lifeguards in Coronado. Wright also worked as a lifeguard at Mission Beach and, according to Coronado lifeguard historian John Elwell, owned a hamburger stand and wrestled as "The Masked Marvel" to earn extra money to support his family. Freeth was well known and well respected in the Southern California beach and surf communities. He was instrumental in starting lifeguard services in Los Angeles County, and he was the "expert" that the grand jury called in to testify after the May 5, 1918, mass drowning at Ocean Beach. Lifeguard and historian Arthur Verge points to Freeth as the father of modern lifeguarding. Residents of Coronado should be proud to know that both Wright and Freeth once patrolled their beautiful beaches.

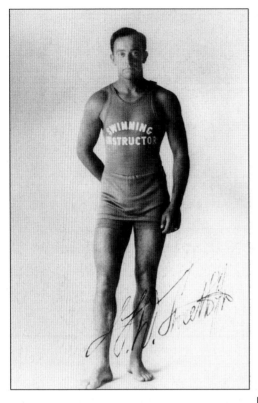

The San Diego Rowing Club hired George Freeth in 1915 to head its aquatics program. Freeth accepted the position and relocated to San Diego from the Los Angeles area. By the fall of 1916, funds for the club were short, and the board voted to discontinue Freeth's employment. (Courtesy of Los Angeles County Lifeguard Association.)

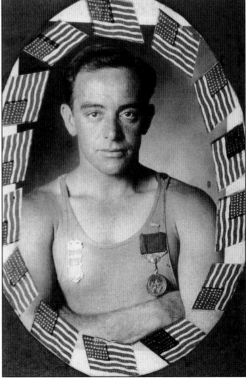

Freeth's credentials as an ocean safety expert were well earned. The recipient of both the U.S. Volunteer Life-Saving Corps' medal for valor and the Congressional Gold Medal, Freeth brought innovation to ocean rescue, using his extensive knowledge of the ocean to his advantage. For example, he taught lifeguards to use the power of a rip current to assist them in swimming to a victim—a practice so common today that it is difficult for modern lifeguards to realize how revolutionary the idea was. (Courtesy of Los Angeles County Lifeguard Association.)

This 1953 publicity photograph of lifeguard Russ Elwell shows him with binoculars in hand and pith helmet on head. Lifeguards frequently used binoculars, but they seldom wore the official pith helmet head gear. They preferred instead the lighter, cooler, and more stylish straw hat. (Courtesy of Russ Elwell.)

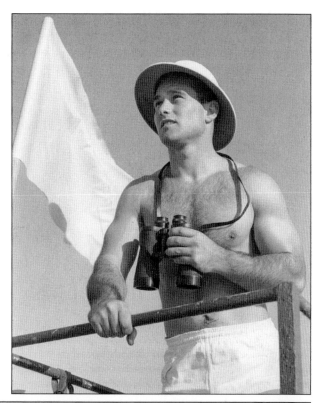

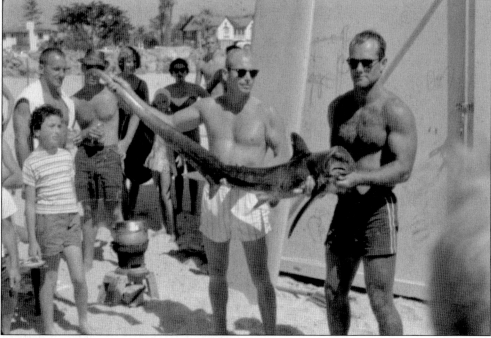

Everyone on the beach started yelling "Shark!" Elwell ran into the water and grabbed the fish by tail. An unknown beach patron helps Elwell (right) hold the creature after it had been dragged from the water. (Courtesy of City of Coronado Lifeguard Service.)

Charles Quinn, a lifeguard at both Coronado City and Imperial Beach, grabs hold of a paddleboard from Australia. Many surfers who became lifeguards brought their ocean knowledge and surf experience, along with their surfboards, to the work of lifeguarding. (Courtesy of Russ Elwell.)

Lifeguards took the longer paddleboards, shortened them, and added handles for victims. Another piece of equipment that lifeguards took advantage of was the army-surplus Jeep. The vehicles were a real boon to lifeguard services for years. (Courtesy of Russ Elwell.)

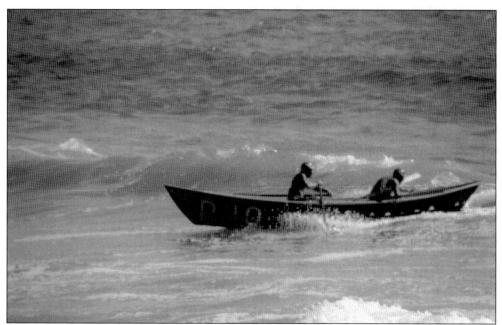

Originally, the surf dory was a lifeguard's primary means of rescue. The rescuers paddled the boat to the struggling victim and threw him a line, then pulled him to the gunwale of the dory, where the lifeguards could yank him on board. Today lifeguards use the boats for racing. (Courtesy of Russ Elwell.)

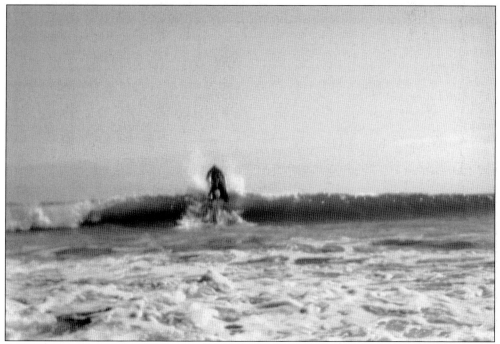

Faster and lighter than the rescue dory, the inflatable rescue boat (IRB) replaced heavier motorized wooden skiffs, which had replaced the dories. The IRBs, though still in use, have been mostly replaced by the jet ski. (Courtesy of City of Coronado Lifeguard Service.)

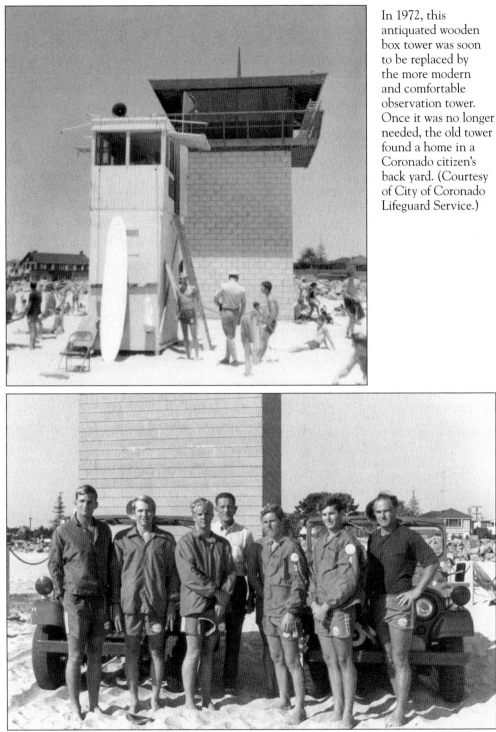

In 1972, this antiquated wooden box tower was soon to be replaced by the more modern and comfortable observation tower. Once it was no longer needed, the old tower found a home in a Coronado citizen's back yard. (Courtesy of City of Coronado Lifeguard Service.)

Coronado lifeguards celebrated the opening of a new main tower in 1972. Pictured in front of the 1954 Willys military surplus Jeeps are, from left to right, Greg Penawick, Larry Cartwright, unidentified, Stan Antrim, Charlie Defay, Mark Hansen, and Russ Elwell. (Courtesy of Russ Elwell.)

The most common reason for a lifeguard to need to rescue someone is the rip current. Before lifeguard services were consistently provided throughout the county, rip currents caused numerous deaths. Here a classic dogleg rip current shows its power off North Beach in Coronado. (Courtesy of Russ Elwell.)

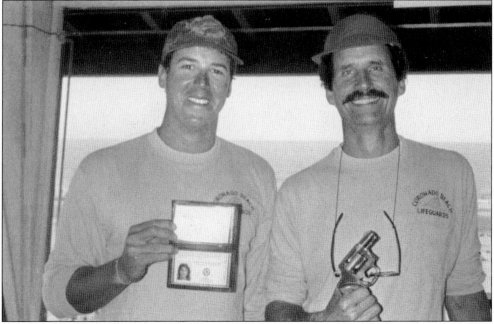

Rob Rand and Mike Neil pose with the identification card and gun of a missing FBI agent. The items, found in an abandoned purse on the beach, led local FBI investigators to search for the missing agent. She turned up at the Hotel del Coronado, having drinks with a friend she met at the beach. (Courtesy of City of Coronado Lifeguard Service.)

As concern grew over protection from the sun, lifeguards slathered on sunscreen. But more innovative and unique lifeguards invented other means of protection. Coronado lifeguard and inventor Jim Cahill presents his "sun suit," made of light fabric and held together with Velcro. Cahill's skeptical lifeguard captain would only allow use of the suit if Cahill could take it off faster than the captain could remove his t-shirt. Cahill demonstrates the speedy removal of his suit. He was allowed to wear it on patrol. As of today, only one sun suit is known to exist. (Courtesy of City of Coronado Lifeguard Service.)

Not only did Russ Elwell keep a watchful eye on the water, but on February 13, 1986, he also had an opportunity to watch under the water, diving to a depth of 3,000 feet. Though the record is not officially verified, it seems safe to say that Elwell most likely has been deeper underwater than any other lifeguard. (Courtesy of Russ Elwell.)

In 1999, a freak lightning strike required lifeguards to clear the beach. Moments before the strike, a lifeguard in his tower called to the central dispatch, "It feels kind of funny down here. I'm closing my tower." (Courtesy of City of Coronado Lifeguard Service.)

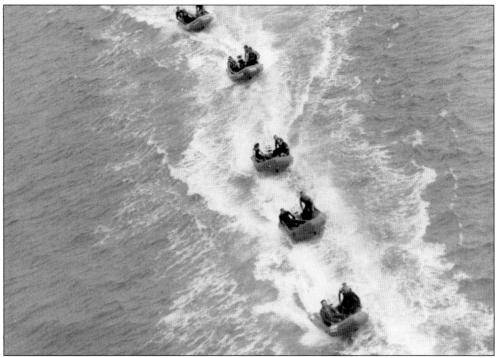

Before jet skis, the preferred surf rescue boat was the IRB. A group of lifeguards go through maneuvers during a 1980s practice session. (Courtesy of City of Coronado Lifeguard Service.)

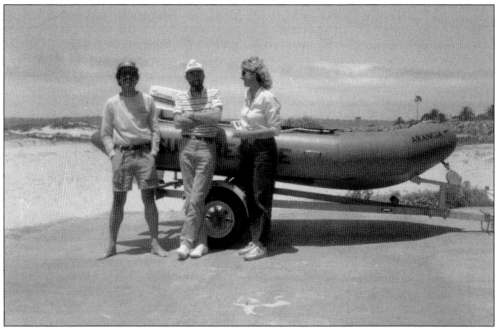

Coronado captain Mike Neil and representatives from Arancia Boats pose with one of the new IRBs purchased by the City of Coronado Lifeguard Service. Today lifeguards have switched to personal watercraft (PWCs) as their primary rescue vessels, but they still use IRBs on occasion. (Courtesy of City of Coronado Lifeguard Service.)

Four

SAN DIEGO

The City of San Diego Lifeguard Service is the oldest municipal lifeguard service in the county. Private bathhouse owners who rented bathing suits and beach umbrellas to visitors were required to have a lifeboat and a rescue buoy on hand, and some bathhouse owners provided lifeguards, as did the city of San Diego. The early lifeguards were under the police department. In a *San Diego Union* article dated May 6, 1918, police lifeguard Louie Chavard is cited as having worked at Ocean Beach for 12 years. This means that the city lifeguard service dates to as early as 1906, although traditional wisdom is that it began in 1918, after the May 5 drowning of 13 people and rescue of 60 others.

Chavard was one of the lifeguards on duty on May 5, 1918, and he was responsible for a number of rescues. Another noted lifeguard present was Calvin "Spade" Burns. He is not cited in the newspaper accounts, but in an interview with Ocean Beach historian Ruth Varney Held, Burns recalled that day. He said that he had a date to go to the dance hall with a girl at 3:00 p.m. When he did not show up for the date, the girl went looking for him down at Ocean Beach and found him there in his bathing suit, making rescues. Burns was the chief lifeguard from 1924 to 1937.

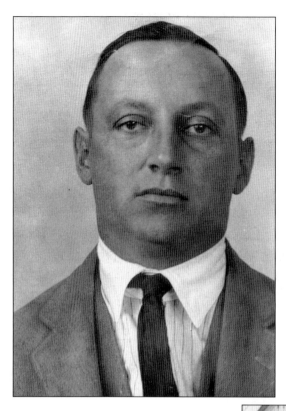

Louie Chavard, also identified as Louis Chauvaud in 1918 newspaper articles, was one of the first lifeguards for the city of San Diego. He worked as a police lifeguard under the chief of police. His service dates back to 1906. (Courtesy of City of San Diego Lifeguard Service.)

Calvin "Spade" Burns was another early lifeguard. His family resided in Ocean Beach, and his father ran a livery stable at the corner of First and Market Streets. Burns stands outside the Ocean Beach station, next to the landline used to tow victims in from the surf. (Courtesy of City of San Diego Lifeguard Service.)

Lifeguards Buchard and Burns stand outside the Ocean Beach lifeguard station. Burns was a favorite among Ocean Beach residents. After his career as a lifeguard ended, he became a commercial fisherman. (Courtesy of City of San Diego Lifeguard Service.)

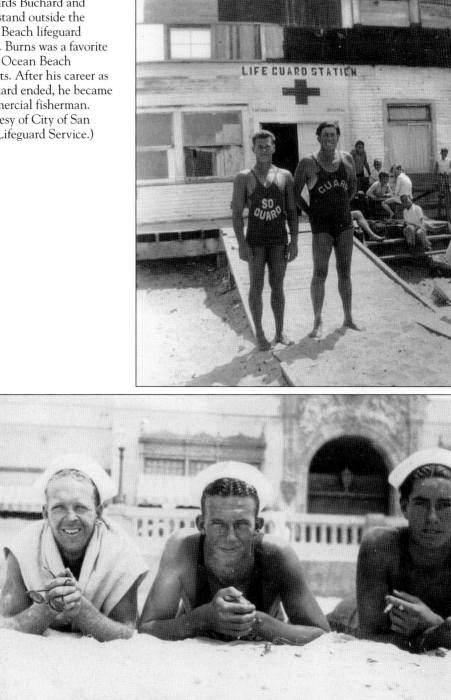

Lifeguard Charles Hardy (middle) relaxes on the beach with two companions. Hardy started his lifeguard career while attending San Diego High School. He worked for the Spreckels Corporation at Mission Beach starting in 1926. (Courtesy of City of San Diego Lifeguard Service.)

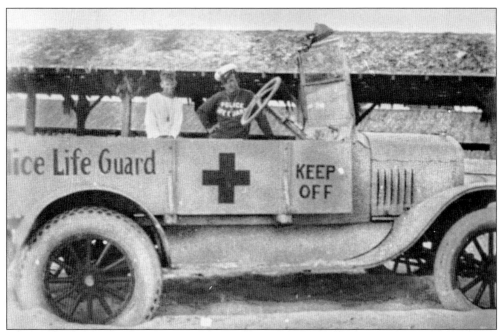

George Stanley (left) and Charles Hardy (right) are ready for duty in the Ford Model T police lifeguard vehicle. The lifeguard service was under the San Diego City Police Department until 1946, when it was transferred to the Parks and Recreation Department. (Courtesy of City of San Diego Lifeguard Service.)

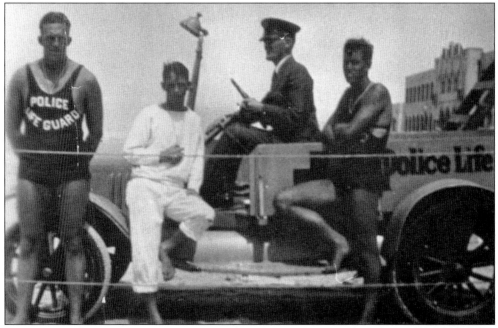

From left to right, lifeguards Hardy, Stanley, Nelson, and Lathers, pictured astride the Model T, are ready for duty in 1927. After the 1927 summer season, Hardy worked in the aircraft industry in Long Beach until 1930, when he returned to San Diego and took a job as a permanent lifeguard. (Courtesy of City of San Diego Lifeguard Service.)

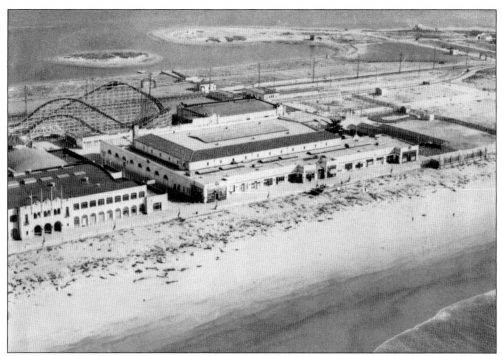

The Mission Beach station has served the City of San Diego Lifeguard Service practically since the organization began. Though the community has grown up around it and the bay has been developed, the station continues to be a central hub of lifeguard operations. (Courtesy of City of San Diego Lifeguard Service.)

The City of San Diego Lifeguard Service's rescue equipment stands ready for deployment. The two dories were used for surf rescue, and lifeguards required constant practice with them. The vehicle, a 1930 Model A Ford Depot Hack with under-inflated tires, stood ready for beach patrol and worked well on the sand. Behind the Model A is a rescue reel. (Courtesy of City of San Diego Lifeguard Service.)

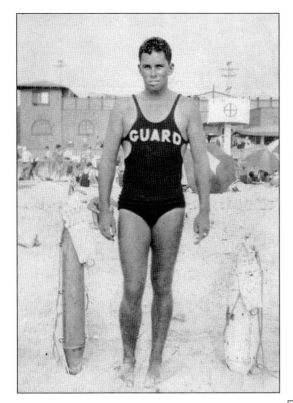

Ed Stotler began his career with the City of San Diego Lifeguard Service as a seasonal lifeguard in June 1928, working the summer for a wage of $100 a month. Six months later, he was appointed to a permanent position, which earned him an extra $15 a month. During the summer season, Stotler worked as a lifeguard on the beach, and during the winter season, he drove in a "prowl" car with a police officer. Stotler and the officer he rode with responded to aquatic rescue calls from Mission Bay to La Jolla. In 1934, Stotler was appointed a patrolman for the city police department, working foot patrol in Logan Heights. He became a detective in 1936. Stotler retired in 1967, after 39 years of service to the city. In the photograph below, he is standing with his wife, Bunny. (Courtesy of City of San Diego Lifeguard Service.)

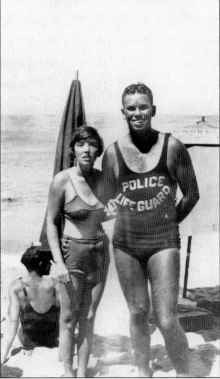

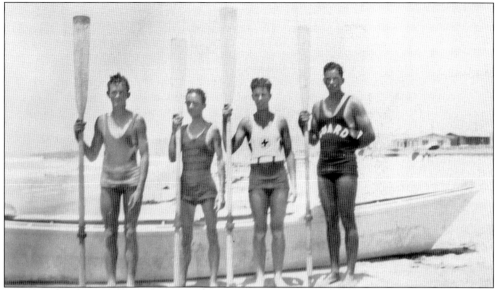

Ed Stotler (far right) had an extremely strong influence on many of the young men who frequented Mission Beach. He is pictured with three companions in front of the rescue dory. Stotler assisted those who wanted to be lifeguards, helping them master the skills necessary for the job. (Courtesy of City of San Diego Lifeguard Service.)

One of the men befriended by Stotler was Emil Sigler. In November 1934, Sigler (left) and William Rumsey rowed Emil's dory up the coast from Mission Beach to Huntington Beach and then out to Catalina. (Courtesy of City of San Diego Lifeguard Service.)

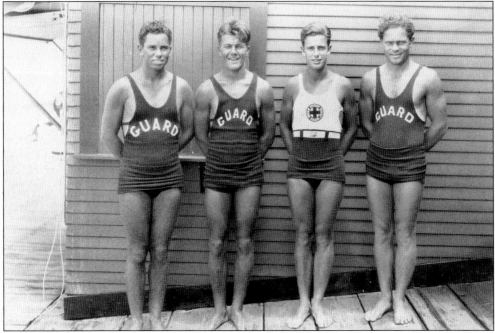

Lifeguard Ed Stotler (far left) and lifeguard Gordon McKenzie (far right) are pictured here with two unidentified people. Lifeguards wore swimsuits that proclaimed "Guard" on the front. A suit with a cross patch on the front signified that the person was trained in Red Cross techniques. Many non-lifeguards proudly wore the patches on their swimsuits. (Courtesy of City of San Diego Lifeguard Service.)

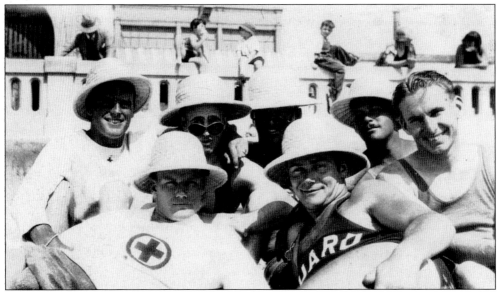

This photograph was taken in the early 1930s, before Emil Sigler became a lifeguard. He is in the back row on the left side. At this time, Sigler had been living in a small one-bedroom apartment above the bathhouse on Mission Beach. Many of his friends were members of the lifeguard service. It was Ed Stotler who encouraged Sigler to become a lifeguard. (Courtesy of City of San Diego Lifeguard Service.)

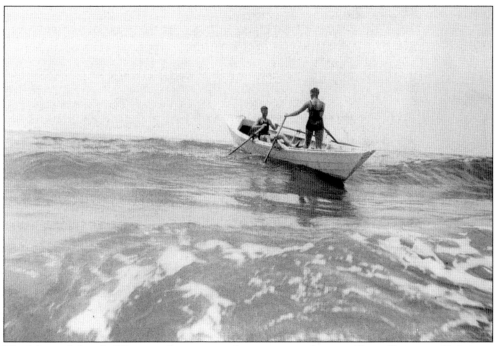

The lifeguards head offshore as they practice their rowing technique. Typically, a seated bowman faced the stern of the boat, while the sternman stood and faced the bow. (Courtesy of City of San Diego Lifeguard Service.)

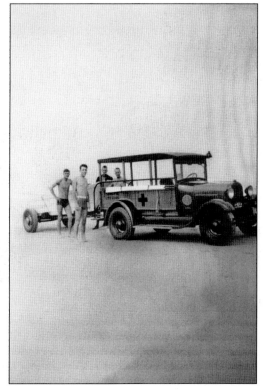

In the 1850s, the rescuers of the U.S. Life-Saving Service had to use horses to tow their dories. The rescuers of the 1930s had the luxury of motorized transportation. The 1930 Ford Model A transported the boat, but once it was deployed, good old-fashioned muscle power was still required to get it through the surf. Motorized rescue boats were still in their infancy at the time. (Courtesy of City of San Diego Lifeguard Service.)

William Rumsey was another leader of the San Diego lifeguards. He started his career in the early 1930s, working his way up to lieutenant in the city service. He was named captain of the newly formed San Diego County Lifeguard Service on May 20, 1941. This photograph was taken on April 21, 1931. (Courtesy of City of San Diego Lifeguard Service.)

Lifeguard Emil Sigler (being carried) and Gordon McKenzie practice a victim-carrying technique. Despite having the use of only his left eye, Sigler started with the City of San Diego Lifeguard Service in June 1934. He lost his right eye in a childhood accident. (Courtesy of City of San Diego Lifeguard Service.)

Ed Stotler and Bill Riley perform the most basic of lifeguard job functions: sitting atop a lifeguard stand and watching swimmers. Tower duty was frequently grueling work. The guards were exposed to all types of elements and had to man their posts unless they were making a rescue. (Courtesy of City of San Diego Lifeguard Service.)

In the late 1930s, controversy erupted along the beach. The San Diego City Council, in an effort to save maintenance money, tapped the city lifeguards to clean up kelp along the beachfront. Councilman Maire said, "Cleaning up a little seaweed won't hurt any of them. If anything the exercise will improve their figures. It will do them good." (Courtesy of City of San Diego Lifeguard Service.)

The inside of the Mission Beach lifeguard headquarters provided a respite from the unprotected lifeguard stand out front. Here Capt. Charles Hardy relaxes while two guards repair equipment and Bill Rumsey mans the desk. (Courtesy of City of San Diego Lifeguard Service.)

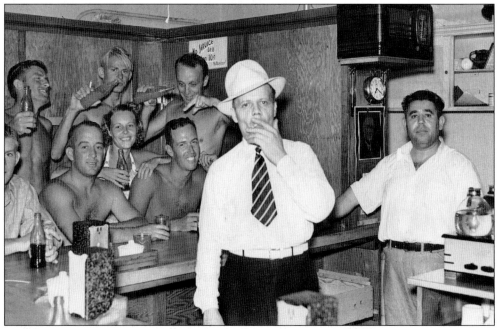

Lifeguards were frequent patrons of the local businesses, buying hamburgers from the local stands and frequenting the local eateries. The clock in this image shows that it is well after the typical 6:00 p.m. tower-closing time. These guards are enjoying some post-work camaraderie and a few cold sodas. (Courtesy of City of San Diego Lifeguard Service.)

When Charles Hardy resumed his lifeguard career in 1930, the force consisted of five men, a Model T Ford, and a motorcycle with a sidecar. Hardy was promoted to supervising lifeguard in 1933, and his title was later changed to captain. During Hardy's tenure, the budget for the service was moved from the police force to the parks and recreation department, which ultimately made it more difficult to compete for funding. But even with this constraint and with the competition for public safety money, Hardy saw the service expand to over 100 men in the busy summer months. Early in his career, Hardy was known as quite a ladies' man. While he held that reputation throughout his life, later in his career his focus changed to the appreciation of good food. Lifeguard Robert Baxley wrote fondly of Hardy's appetite for abalone sandwiches. (Courtesy of City of San Diego Lifeguard Service.)

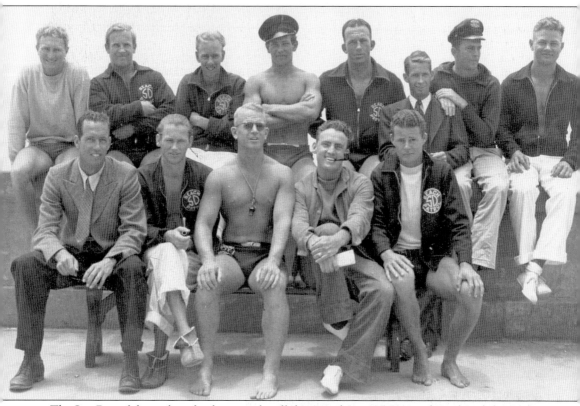

The San Diego lifeguards sit for the annual staff photograph in 1935. Pictured are, from left to right, the following: (first row) Fred Crowther, ? Knudsen, Bill Rumsey, Bill Riley, and Roy Penwarden; (second row) Walt Shaktiack, Emil Sigler, Earl Russell, Dorian "Doc" Paskowitz, Capt. Chuck Hardy, George Stanley, Bill Brenmar, and Huntley Gordon. In an interview with David Aguirre, Sigler recalled, "I remember my first check, 25 dollars for the week. Some of us would moonlight working at a ballroom dance hall. Chuck, Dorian, Bill Rumsey and I would work the doors and throw out the rowdy drunks." (Courtesy of City of San Diego Lifeguard Service.)

Lifeguard Fred Crowther and Capt. Charles Hardy work the lifeguard tower in front of the Mission Beach headquarters. The lifeguards were featured in an August 18, 1940, newspaper article about lifeguards and rescue techniques. (Courtesy of City of San Diego Lifeguard Service.)

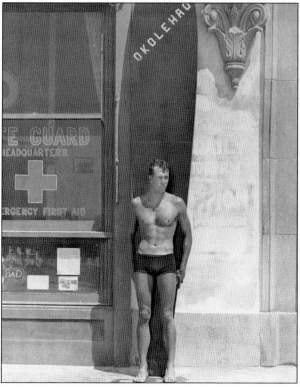

Fred Crowther displays the physical attributes that beach patrons associate with a lifeguard. A 1949 newspaper article credits Crowther with "the longest and fastest run yet made from Mission Bay with the lifeguard speed boat." Crowther and George Stanley made the run, responding to a burning cabin cruiser off Bird Rock in La Jolla. (Courtesy of City of San Diego Lifeguard Service.)

San Diego lifeguards, led by Capt. Chuck Hardy (far left), participate in a night rescue. Though nighttime aquatic emergencies did not occur frequently, lifeguards did respond to them. Some were called at their homes, while many who lived in the area would see the action and respond. (Courtesy of City of San Diego Lifeguard Service.)

Capt. Chuck Hardy is involved in yet another night operation. In 1938, the *Stella Maris* went aground in the evening during a big winter storm. The boat washed up on North Mission Beach. (Courtesy of City of San Diego Lifeguard Service.)

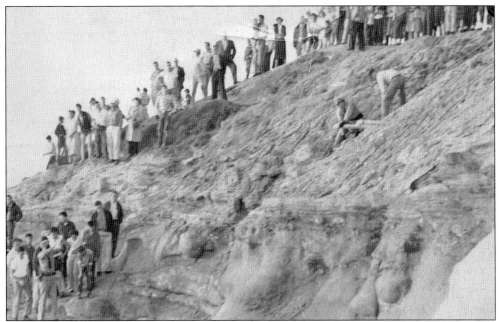

Night rescues are not the only challenges faced by San Diego lifeguards. The cliffs along Sunset Cliffs often proved too big a temptation to adventurous beach patrons. Anyone stuck on the cliffs faced a plunge into the water or a treacherous climb up. In addition to the problem of extricating the victim safely, crowd control was another big issue. (Courtesy of City of San Diego Lifeguard Service.)

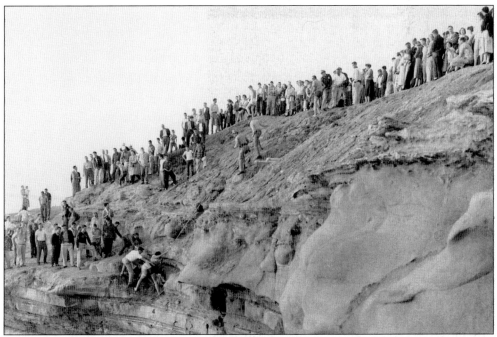

Lifeguards and police, working cooperatively, secured a stout rope on the cliff top and climbed down to the waiting victim. It would be a long time before the use of helmets, belay lines, and harnesses for securing the victim. (Courtesy of City of San Diego Lifeguard Service.)

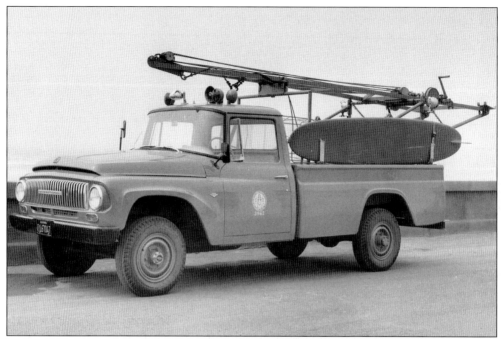

In the 1960s, the rescue capabilities of the San Diego lifeguards were greatly enhanced by their cliff rescue rig. The 1966 International Harvester 1200 featured a movable boom that could be set at the most advantageous angle for dropping a rope over the side or for bringing the victim up the side of the cliff. (Courtesy of City of San Diego Lifeguard Service.)

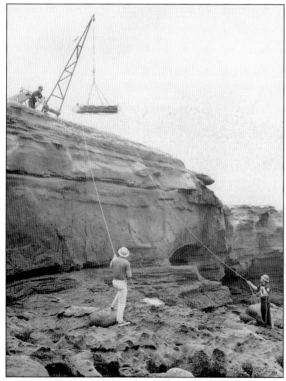

A lifeguard above operates the pulley and winch system to bring the victim to the cliff top, while lifeguards below hold lines to help keep the basket from hitting the side of the cliff. (Courtesy of City of San Diego Lifeguard Service.)

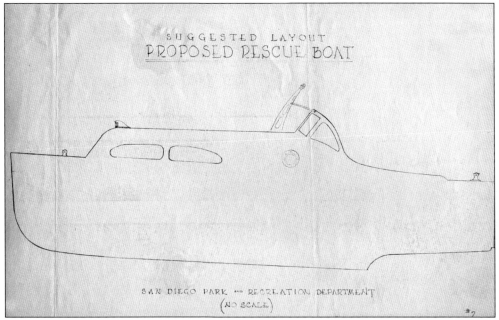

SUGGESTED LAYOUT
PROPOSED RESCUE BOAT

SAN DIEGO PARK — RECREATION DEPARTMENT
(NO SCALE)

#2

Another specialized piece of rescue equipment that made a lifeguard's job easier was the patrol boat. By the 1950s, dories were a relic from the past, and motorized boats were the preferred rescue vessel of lifeguards. Above is an October 1950 sketch of a rescue boat. Below, the drawing has been brought to life as a fully functional vessel in May 1955. It is seen here making its maiden voyage in the channel near Mission Beach. (Courtesy of City of San Diego Lifeguard Service.)

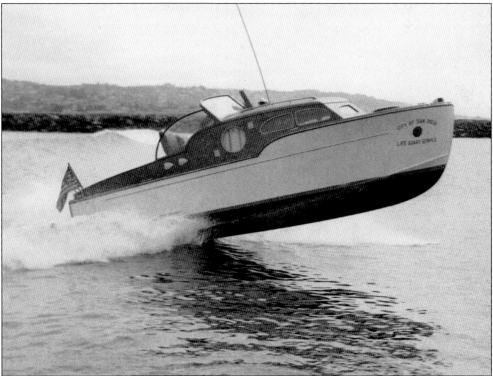

Throughout the years, the resuscitation techniques used to help revive unconscious swimmers have changed dramatically. Here young lifeguards in 1945 learn the technique popular at the time. (Courtesy of City of San Diego Lifeguard Service.)

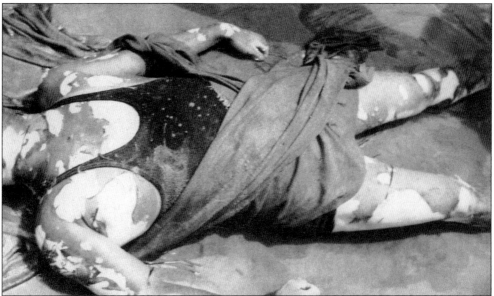

Regardless of the technique, resuscitation rates for victims who have been underwater for more than six to eight minutes are extremely low. No matter what the era, the responsibility on the shoulders of a lifeguard is that of life and death, as this image of a 1930s victim dramatically illustrates. (Courtesy of City of San Diego Lifeguard Service.)

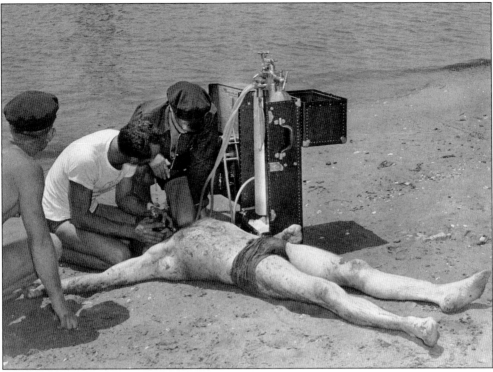

Captain Hardy and two unidentified lifeguards provide oxygen to an unconscious swimmer. (Courtesy of City of San Diego Lifeguard Service.)

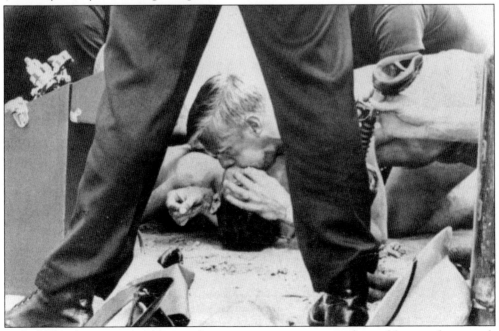

In the 1950s, the resuscitation position for an unconscious victim was changed from on the stomach to on the back. Rescuers actively provided breath for the patient until a resuscitation unit could be set up to deliver oxygen. (Courtesy of City of San Diego Lifeguard Service.)

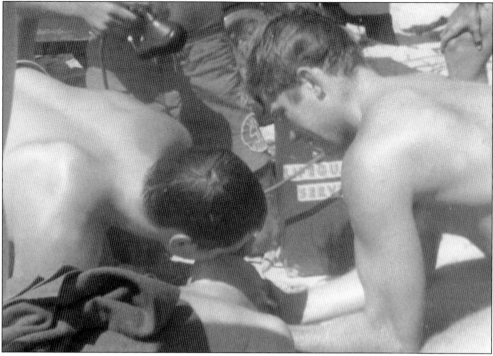

In the 1960s, resuscitation techniques had not changed much from the 1950s. Lifeguards work together to revive an unconscious victim. (Courtesy of City of San Diego Lifeguard Service.)

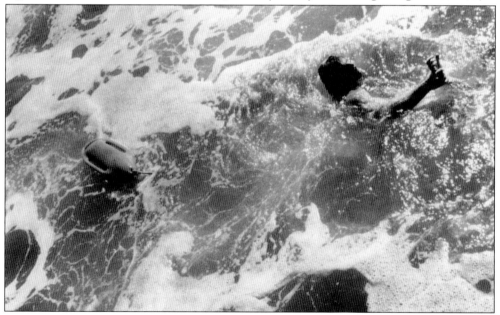

The City of San Diego Lifeguard Service has the longest service record of any agency in San Diego County. Their long tradition has set a standard of excellence aspired to by all lifeguards. Lifeguards will gladly spend hours watching the water and will revive victims as required, but they all have the common goal of drowning prevention—even if it is the grab of a hand just in time. (Courtesy of City of San Diego Lifeguard Service.)

Five

DEL MAR

The municipal lifeguard service of Del Mar began on March 1, 1965, when the city hired Gardner Stevens from the Los Angeles City Lifeguard Department to serve as captain. Stevens's job was to implement and run the new service in Del Mar. Before 1965, the San Diego County lifeguards had provided lifeguard service to Del Mar. Thus continued the slow decline of the county service as yet another city assumed responsibility for lifeguard operations along its municipal beach front.

All of the duty logs for the City of Del Mar Lifeguard Service are still in existence, thanks to Sgt. Jim Lischer, the de facto historian of the lifeguard service. Because of these logs, a great deal is known about Stevens's first day on the job. His shift started at 8:30 a.m., and he washed his assigned patrol car and noted that it was "running good." Through the day, Stevens checked available equipment, sent applications to prospective lifeguards, made arrangements to change the lock on the Twenty-Fifth Street lifeguard tower, hobnobbed at city hall, and checked on more equipment. At about 3:00 p.m., he had time for a sandwich at Robin Hood. He patrolled the beach and noted "lots of dogs loose—long rips—low tide." He attended a city council meeting from 7:30 p.m. until 10:00 p.m., and finally made it to bed at the fire station by 11:15 p.m.

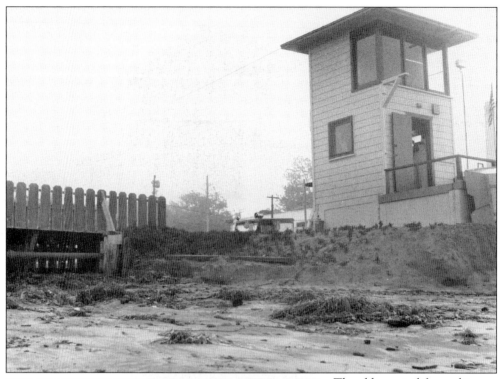

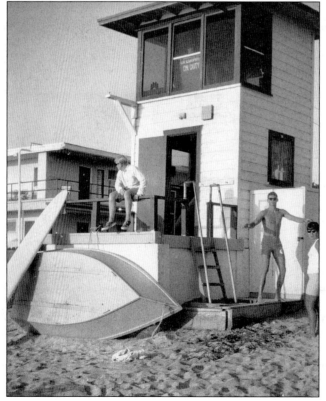

The old county lifeguard tower on Seventeenth Street in Del Mar is open for business under new ownership. Capt. Gardner Stevens was the sole occupant on March 1, 1965. The tower would be in the process of replacement by June of that year. (Courtesy of City of Del Mar Lifeguard Service.)

The paddleboard and rowboat were inherited tools of the trade. Though it was not ideal for heavy surf, the boat could handle the more routine rescues. (Courtesy of City of Del Mar Lifeguard Service.)

On June 20, 1965, Capt. Gardner Stevens oversees his domain from the new tower, which is still under construction. On the beach, Gardner's son Bo (far right) hangs out with his buddies and admires his dad's new office. The tower has since been remodeled and expanded. (Courtesy of City of Del Mar Lifeguard Service.)

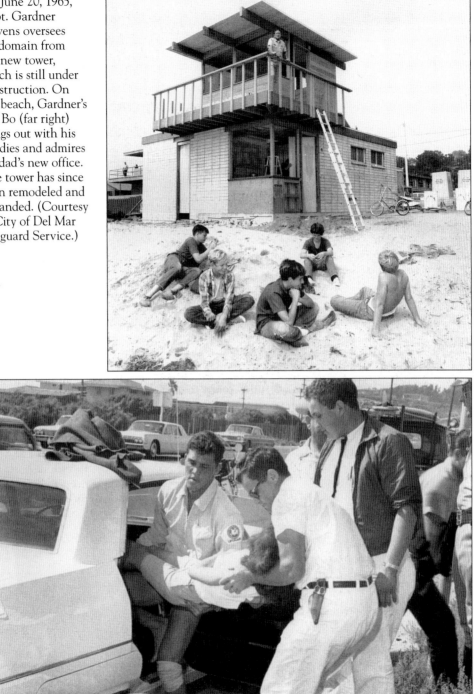

Del Mar lifeguard Ron Jensen, one of the first two lifeguards hired by Stevens, assists medics in removing an accident victim along the coast highway. Frequent accidents meant that lifeguards needed to be able to provide more than just aquatic rescue services to those visiting the coast. (Courtesy of Tom Keck.)

Members of the Del Mar Surf Club often volunteered their services to assist with training new Del Mar lifeguards. Jeff Davies carries an "unconscious" volunteer up the beach during a rescue drill. (Courtesy of City of Del Mar Lifeguard Service.)

Capt. Gardner Stevens, pictured behind the wheel of a 1973 Jeep CJ-5, enjoys an oceanfront meeting with Lt. Bob Neil (center) and Sheriff's Deputy Tom Fields. (Courtesy of City of Del Mar Lifeguard Service.)

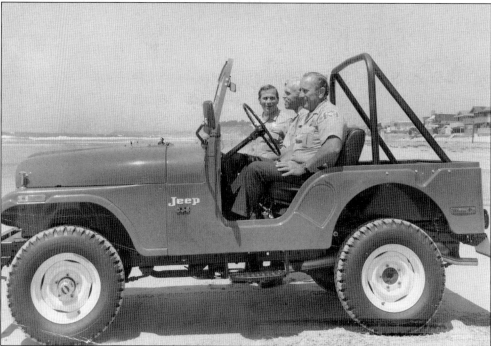

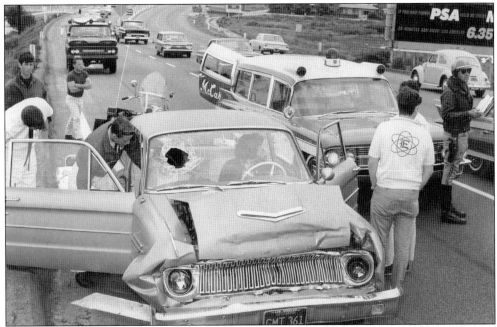

During their tenure along the coast in Del Mar and Solana Beach, the county lifeguards responded to a number of vehicle crashes along the coast highway. Once they took over responsibility from the county, the Del Mar lifeguards also responded. This crash on the northbound coast highway is typical for the area. It is a fair bet that the passenger was not wearing a seatbelt. (Courtesy of Tom Keck.)

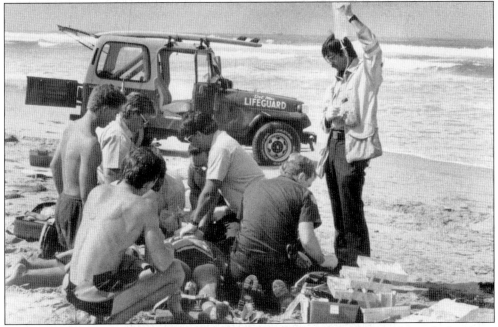

These Del Mar lifeguards and paramedics work on a victim in the 1980s. Although they have the conveniences of a covered Jeep and modern medical supplies, the essence of their job is the same as it has always been. (Courtesy of City of Del Mar Lifeguard Service.)

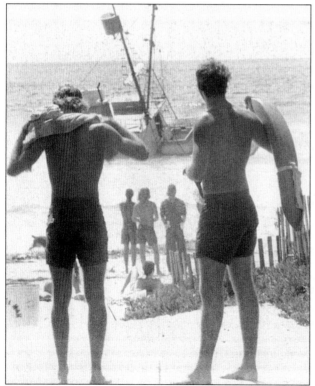

Lifeguards in the tower spotted black smoke coming from this fishing boat when it was well over a mile off shore. The two panicked crew members steamed toward the beach, where they were rescued by lifeguards Grant Larson and Brad Smith. With the men safely on shore, the story behind the incident became clearer. The two men who were operating the boat had stolen it from San Diego Harbor. While they were making their escape, the engine started burning up. The would-be thieves, unwilling to go down with the ship, brought it into the nearest beach, which happened to be Del Mar. In the ensuing confusion after the rescue, the two men managed to slip off into the crowd before their true identities were revealed. (Courtesy of City of Del Mar Lifeguard Service.)

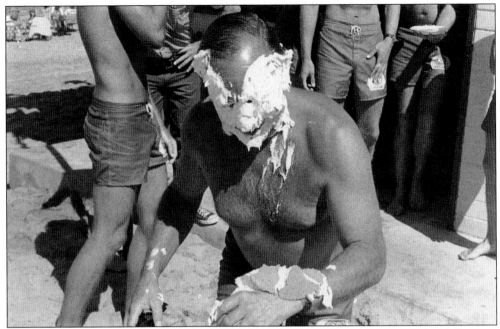

Fun-loving Gardner Stevens started a yearly tradition with his lifeguards. During his full tenure as lifeguard captain, Stevens and his crew did not lose a single swimmer to drowning when they were on duty. At the completion of each successful season, lifeguards had the opportunity to provide the captain with a cream pie to celebrate their safety record. (Courtesy of City of Del Mar Lifeguard Service.)

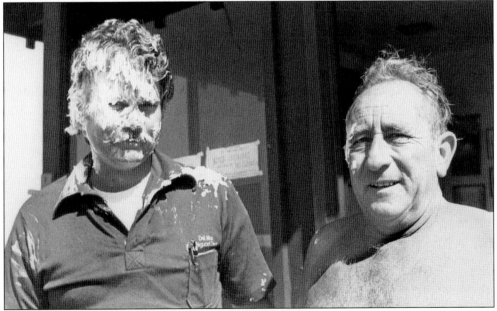

When Stevens retired in 1982, Grant Larson assumed the responsibility for running the lifeguard service. Larson did not let the season-ending tradition fade away. Here, he shares the tradition with Stevens at the conclusion of the summer. Larson was captain until his retirement in 1998. (Courtesy of City of Del Mar Lifeguard Service.)

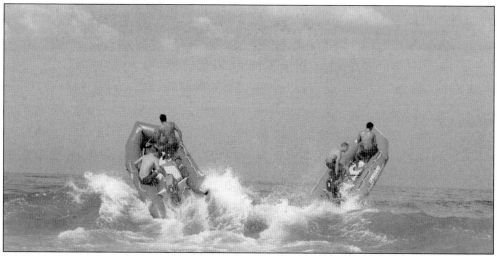

Like many lifeguard agencies in the 1980s, Del Mar utilized the rigid-hull IRB. Though IRBs are not as prevalent today due to the popularity of jet skis as rescue vessels, the lifeguards of Del Mar do still use them. (Courtesy of City of Del Mar Lifeguard Service.)

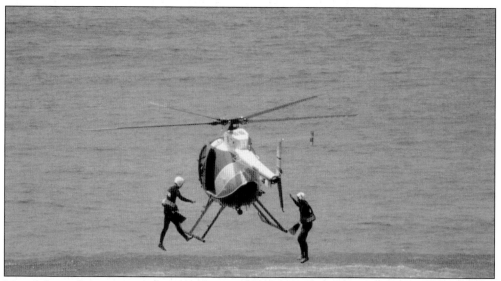

Most lifeguard agencies in the county are not big enough or well-funded enough to have a helicopter dedicated to rescue work. This does not mean that helicopters are unavailable. Here, Del Mar lifeguards work with the sheriff's ASTREA (Area Support To Regional Enforcement Agencies) helicopter, deploying rescuers from the helicopter's skids. (Courtesy of City of Del Mar Lifeguard Service.)

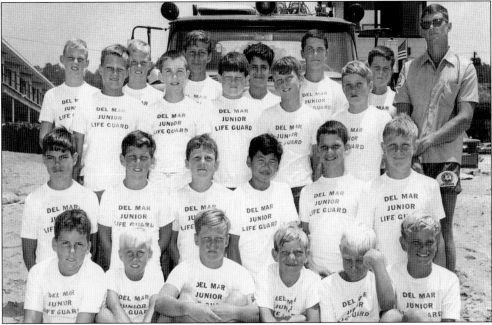

With the old county lifeguard tower in the background, the members of the first Del Mar junior lifeguard class proudly display their new T-shirts in 1965. Many current lifeguards began their careers as junior lifeguards. (Courtesy of City of Del Mar Lifeguard Service.)

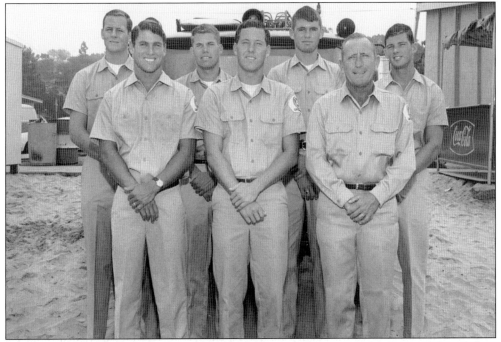

The Del Mar lifeguards look dapper in their official uniforms in 1966. Pictured from left to right are the following: (first row) Tom Cozens, unidentified, and Gardner Stevens; (second row) Brad Smith, Grant Larson, Chris Albertson, and Jack Ross. (Courtesy of City of Del Mar Lifeguard Service.)

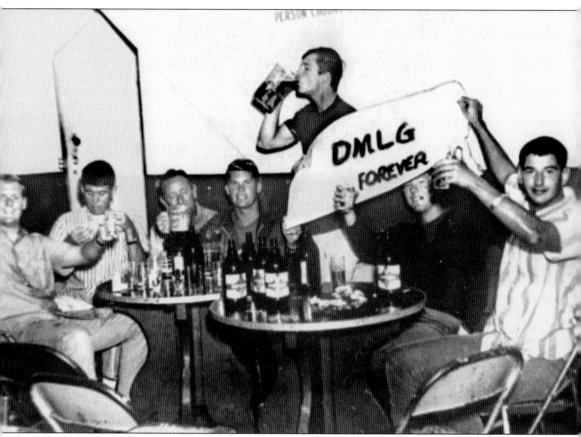

The Del Mar lifeguards pose for a less formal photograph as they celebrate another successful summer's end. Living so close to Tijuana, the lifeguards of San Diego County often went south of the border for their parties. Pictured from left to right, Brad Smith, Chris Albertson, Gardner Stevens, Grant Larson, Jack Ross, Scott Williams, and Dave Kahn celebrate in style. Coworker Tom Cozens snapped the shot. (Courtesy of Tom Cozens.)

Six

SOLANA BEACH

The Solana Beach lifeguard headquarters is the epicenter of the San Diego County Lifeguard Service. When the county supervisors eventually voted to fund a county lifeguard service, they approved enough money to have one man stationed at the Solana, Encinitas-Leucadia, Del Mar, and Imperial Beaches. The civil service test for those desiring a job with the new lifeguard service was held at Mission Beach on May 5, 1941. Capt. Chuck Hardy of the City of San Diego Lifeguard Service, along with San Diego police officers Paul Shea, George Evans, and Ed Stotler, served as judges for the exam. Twenty-eight candidates participated in the test, which included "handling of lifeboats, carrying lifelines, the use of resuscitators, the breaking of grips used by drowning persons, and pulling 'unconscious' victims through pounding waves," according to the *San Diego Union*. William Rumsey, a lieutenant for the City of San Diego Lifeguard Service, was the "only one for appointment by the county as a lifeguard captain." On May 20, 1941, his first day as the newly appointed captain, Rumsey reported to work at Twenty-Fifth Street in Del Mar, where the first headquarters was located. In 1943, Rumsey and lifeguard John Rigon used lumber from Camp Callan at the Torrey Pines military base to build the station in Solana Beach that still stands today.

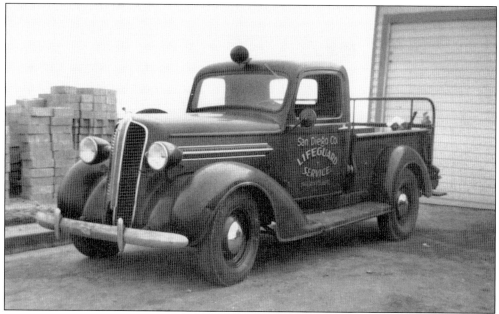

Starting with $1,200 and a 1933 Dodge Express, William Rumsey instituted the county lifeguard service. His first work station was at Twenty-Fifth Street in Del Mar. A small bluff in Solana Beach provided an area for a future building. When Rumsey began the service in June 1941, the bluff existed, but the building had yet to be constructed. (Courtesy of City of Solana Beach Lifeguard Service.)

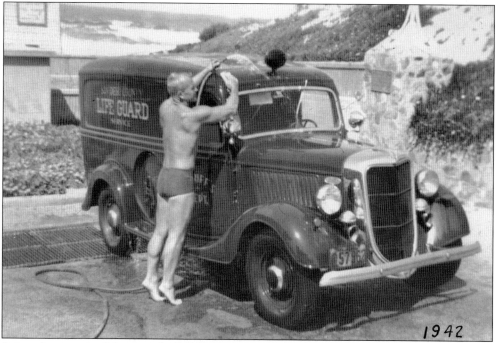

Being the captain did not make Bill Rumsey immune to the day-to-day chores of equipment maintenance. Here the captain knocks the salt deposits off the San Diego County Sheriff's 1935 Ford panel truck. (Courtesy of City of Solana Beach Lifeguard Service.)

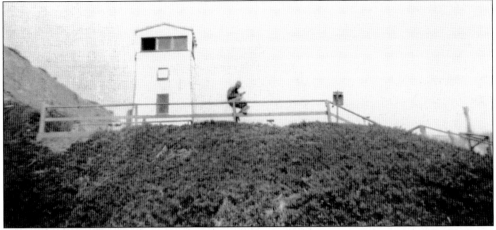

A ukulele-strumming lifeguard surveys the crowd below from his vantage point on the bluff top. This photograph was taken in 1941 or 1942, before the county headquarters was built at Solana Beach. (Courtesy of City of Solana Beach Lifeguard Service.)

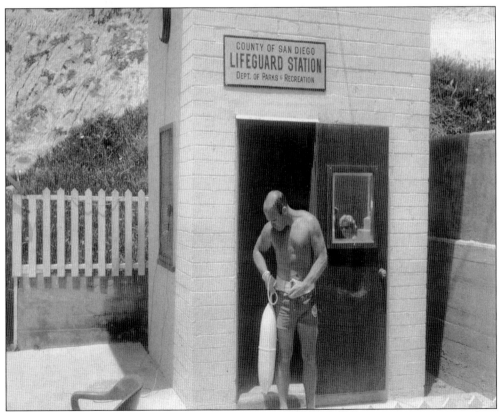

Lifeguard Mike Considine checks the belt on his rescue tube outside the lifeguard tower at Solana Beach. Considine eventually became a lieutenant for the county lifeguard service. (Courtesy of City of Solana Beach Lifeguard Service.)

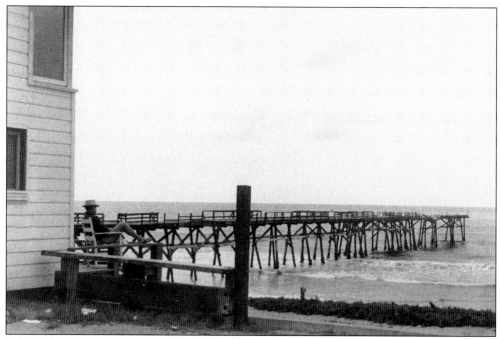

Lifeguard Knox Harris sits at his post in Del Mar. Harris was a well-known lifeguard who befriended many beachgoers who frequented the area. He counted actors Pat O'Brien and Desi Arnaz among his friends. (Courtesy of City of Solana Beach Lifeguard Service.)

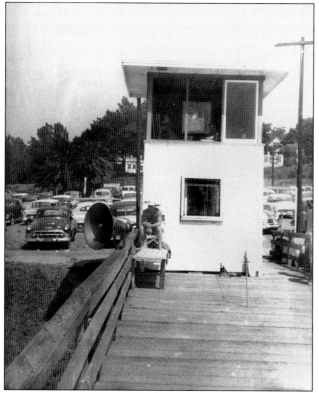

As in all the county towers, a large speaker stood ready to amplify the warning voice of the watchful lifeguard. The Del Mar pier lasted until February 1959, when it was blasted apart by a Navy demolition team. (Courtesy of City of Solana Beach Lifeguard Service.)

The county lifeguard truck, a 1933 Dodge, is seen on the beach in Del Mar. Though they were headquartered at Solana Beach, the county lifeguards were responsible for safety on beaches from Encinitas to La Jolla. (Courtesy of City of Solana Beach Lifeguard Service.)

Up the coast from Del Mar is the area known as Tide Park, located just south of Table Top Reef in Cardiff. No lifeguard station has been built there yet. (Courtesy of City of Solana Beach Lifeguard Service.)

Lifeguard John Brennan is pictured here in 1946. Brennan worked for both the City of San Diego Lifeguard Service and the county lifeguard service. Later, he worked in the San Diego City Manager's office. (Courtesy of City of Solana Beach Lifeguard Service.)

Lifeguard William "Red" Shade is seen here in 1957. Shade started his lifeguard career with the City of San Diego Lifeguard Service in 1941. He eventually transferred over to the county service, where he worked until 1981. In addition to being a lifeguard, Shade was also a professional musician. (Courtesy of City of Solana Beach Lifeguard Service.)

Lifeguard Kimball Daun is seen here in 1957. He was part of a group of kids that Emil Sigler named "the vandals." Daun was a detective for the San Diego Police Department, and he worked for the San Diego County Lifeguard Service from 1946 to 1960. (Courtesy of City of Solana Beach Lifeguard Service.)

Lifeguard Raymond "Skeeter" Malcolm is pictured in 1946. Malcolm was a principal for the San Diego City School District. He died in 1993 at the age of 71. (Courtesy of City of Solana Beach Lifeguard Service.)

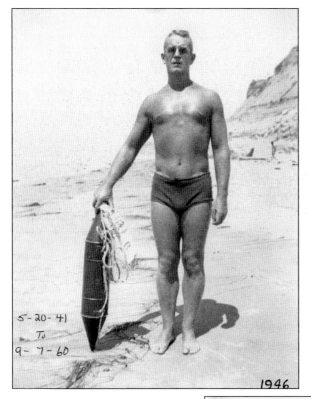

5-20-41
To
9-7-60

1946

San Diego County lifeguard captain Bill Rumsey is seen here in 1946. Rumsey, who spent his early career with the City of San Diego Lifeguard Service, became the captain of the newly formed county lifeguard service on May 20, 1941. He served until September 7, 1960. (Courtesy of City of Solana Beach Lifeguard Service.)

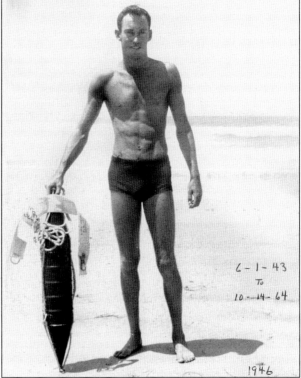

6-1-43
To
10-14-64

1946

Lifeguard Pat Kahlow is pictured here in 1946. Kahlow worked for the county lifeguards from June 1, 1943, until October 14, 1964. He became captain of the service when Bill Rumsey retired. (Courtesy of City of Solana Beach Lifeguard Service.)

Three unidentified lifeguards pose with their 1930 Ford Huckster patrol truck. The board attached to the rail on the right side of the vehicle is printed with the words "Beach Patrol." (Courtesy of City of Solana Beach Lifeguard Service.)

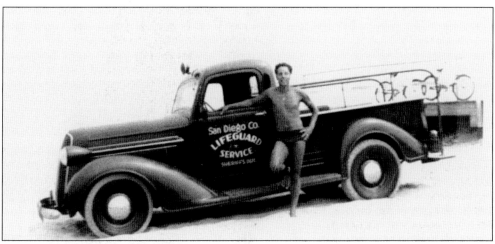

Lifeguard Knox Harris poses with the sheriff's department's 1933 Dodge Express. The lifeguards used the truck for beach patrol. (Courtesy of City of Solana Beach Lifeguard Service.)

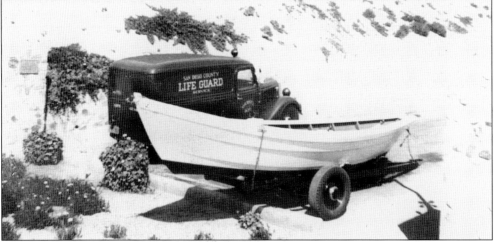

The 1935 Ford panel truck stands ready with the rescue dory at the Solana Beach headquarters. Lifeguards used the rescue dories into the 1950s, when they were replaced by motor-powered rescue skiffs. (Courtesy of City of Solana Beach Lifeguard Service.)

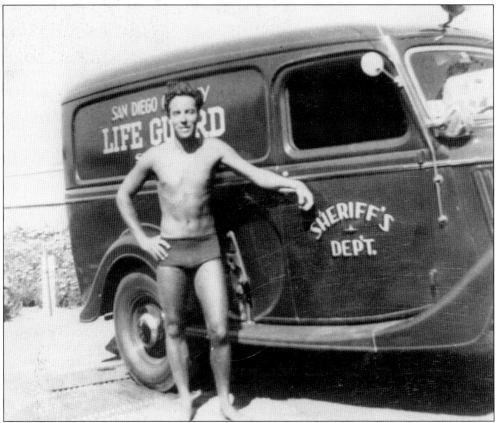

Knox Harris stands beside his patrol truck. When it was originally implemented, the San Diego County Lifeguard Service was placed under the authority of the sheriff's department. Later, it was transferred to the parks and recreation department. (Courtesy of City of Solana Beach Lifeguard Service.)

Bill Rumsey and a number of other candidates participated in tryouts for the San Diego County Lifeguard Service on May 5, 1941. On May 20, 1941, Rumsey was appointed captain. (Courtesy of City of Solana Beach Lifeguard Service.)

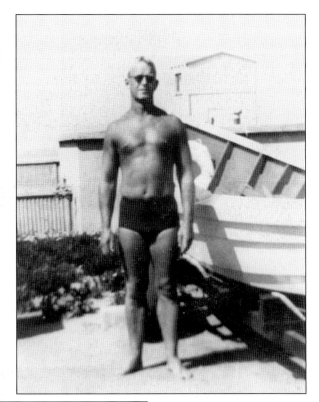

In addition to working for the county lifeguard service, John Elwell became a teacher, a world traveler, and a writer specializing in Southern California surf history. He still lives in Coronado. His brother Russ worked for City of Coronado Lifeguard Service and the City of Imperial Beach Lifeguard Service. (Courtesy of Tom Keck.)

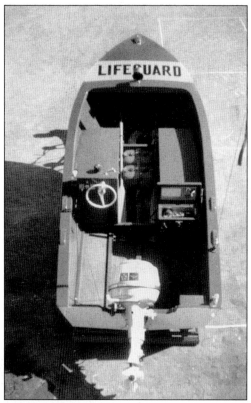

The county lifeguards maintained a rescue boat for use along the coast. The boat, prepared and ready for deployment, was stored at the Solana Beach station. (Courtesy of City of Solana Beach Lifeguard Service.)

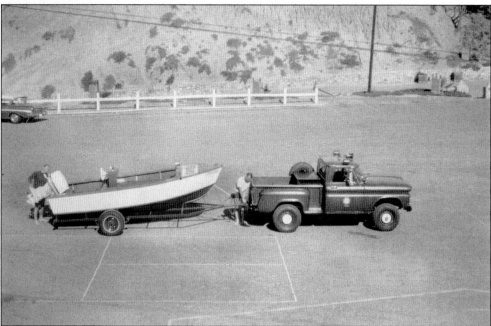

A lifeguard attaches the rescue boat to the 1964 Chevy C-10 pickup. County lifeguards deployed the rescue skiffs as far south as Imperial Beach. (Courtesy of City of Solana Beach Lifeguard Service.)

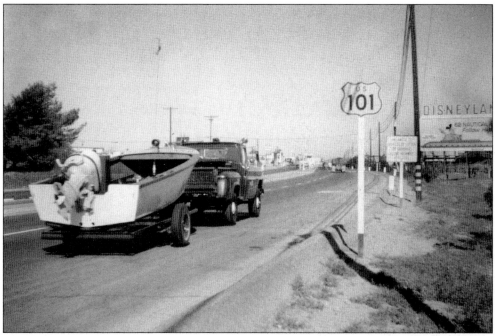

The boat is securely attached and under tow as the lifeguards head north along the coast highway for a deployment in Encinitas. (Courtesy of City of Solana Beach Lifeguard Service.)

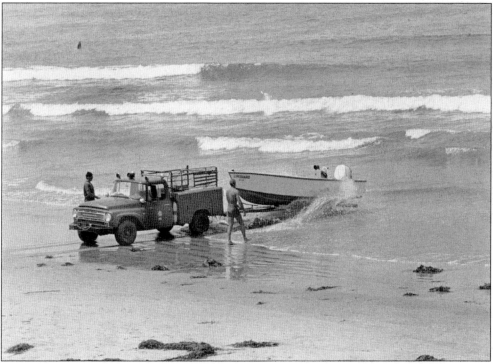

County lifeguards deploy the rescue skiff along the shoreline. Like their predecessors, who used the rowed surf dory, they required constant practice in the proper launching and maneuvering of the boat through the incoming surf. (Courtesy of City of Solana Beach Lifeguard Service.)

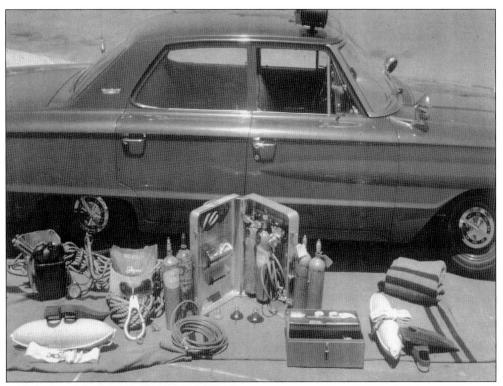

This 1964 Ford Galaxy 500 is outfitted with all the latest rescue gear, including rope for cliff rescues, a first-aid kit, a wool blanket, two sets of rescue tubes and fins, and a resuscitation kit with extra oxygen bottles. (Courtesy of City of Solana Beach Lifeguard Service.)

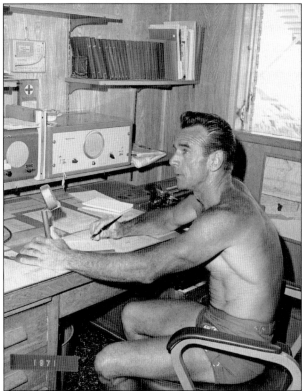

Lifeguard captain Jim Lathers is at the radio dispatch center for the San Diego County Lifeguards in Solana Beach. Lifeguards fielded radio calls and dispatched units from this location. On the shelf above Lathers are the yearly patrol logs. These books, which are still in existence, preserve the firsthand records of daily lifeguard activity. (Courtesy of City of Solana Beach Lifeguard Service.)

San Diego County lifeguards manned the tower at Moonlight Beach before the California State Parks lifeguards took over operations, followed by Solana Beach lifeguards and then Encinitas lifeguards. (Courtesy of City of Solana Beach Lifeguard Service.)

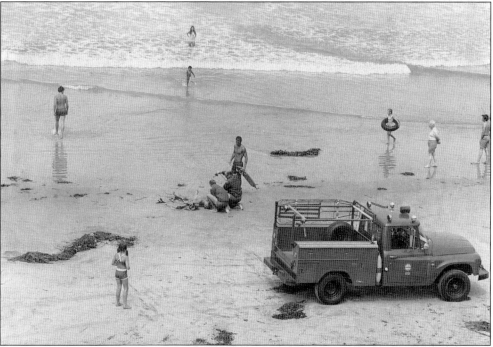

Just south of Moonlight Beach, county lifeguards respond in their International Harvester 1200 to a drowning victim. With the exception of the little girl in the foreground, the beach patrons seem unaware of the seriousness of the call. (Courtesy of Tom Keck.)

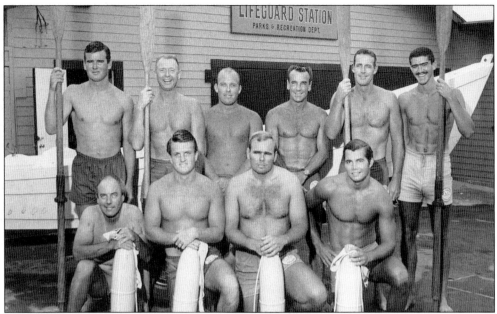

This is the San Diego County lifeguard staff in the mid-1960s. By this time in the service, the surf dory was no longer used for rescues, though it was paddled for exercise and for offshore fishing expeditions. Pictured are the following, from left to right: (first row) Knox Harris, unidentified (possibly Bob Schaer), Bill Hunt, and Pete Zovanyi; (second row) John Hunt, Red Shade, Mike Considine, Jim Lathers, John Bowen, and unidentified. (Courtesy of Tom Keck.)

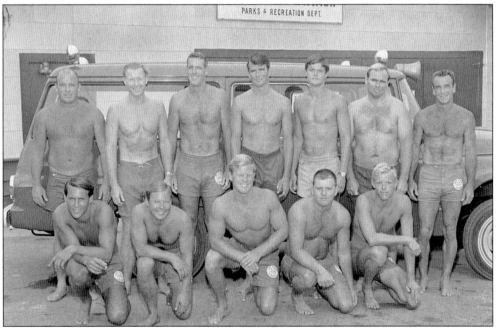

This photograph of the San Diego County lifeguards was taken in the early 1970s. Behind the lifeguards is a mid-1960s International Travelall. The people in the first row are unidentified. In the second row, from left to right, are Mike Considine, Red Shade, John Bowen, John Hunt, Pete Zovanyi, Bill Hunt, and Jim Lathers. (Courtesy of Tom Keck.)

Capt. Pat Kahlow and Lt. Jim Lathers shake hands in front of the new rescue skiff in 1961. Lathers had been working at the county station in Imperial Beach, but he transferred to Solana Beach in 1956 when the city of Imperial Beach incorporated and took over control of lifeguard services. (Courtesy of City of Solana Beach Lifeguard Service.)

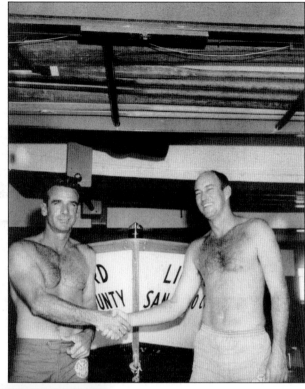

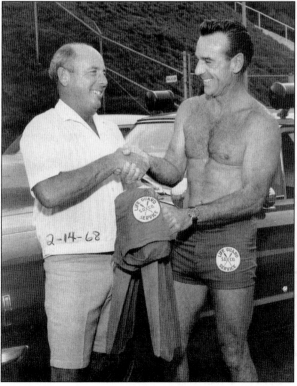

Capt. Jim Lathers congratulates lifeguard Knox Harris on a 27-year career in the county lifeguard service. Harris began his career in the inaugural summer of 1941. He retired in 1968 due to an Achilles injury that he suffered during a rescue in June 1967. (Courtesy of City of Solana Beach Lifeguard Service.)

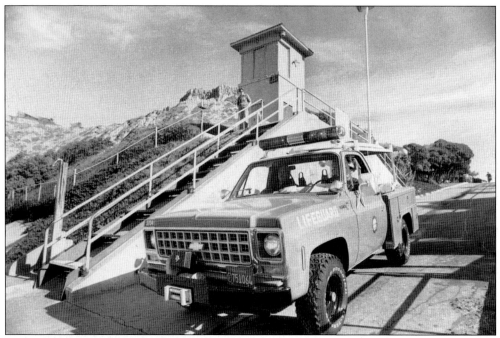

This photograph was inscribed "To Andy, Paul, Scott and the boys. I had fun covering stories down here. Watch out for sharks." It was signed by Joe Hessian. Here, the lifeguards patrol in a 1980 Chevy C-10 pickup. The tower in the background succumbed to storm damage in the winter of 1983 and had to be torn down. (Courtesy of City of Solana Beach Lifeguard Service.)

Solana Beach lifeguard captain Paul Dean started his career with the San Diego County Lifeguard Service in 1971. When Solana Beach incorporated, he stayed with the new city lifeguard service. Dean retired as captain in 2003. Though it is no longer run by the county lifeguards, the old county station still serves the city lifeguards today. (Courtesy of City of Solana Beach Lifeguard Service.)

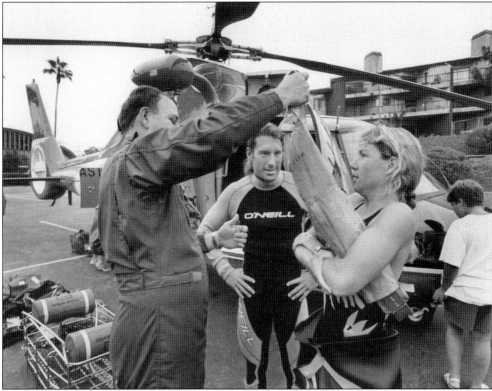

Seen here on July 30, 1991, lifeguards and Coast Guard members train together, practicing extrications from the ocean. The rescuing lifeguards put the "horse collar" around themselves and hold tightly to the victims while the helicopter hovers above. In heavy surf conditions, the HH-65 Dolphin helicopter can pull lifeguard and victim from the calmer water outside the large waves. Coast Guard PO2 Jon Virt show lifeguards Frederil Yerger and Heidi Freudenstein the proper hoisting technique. (Courtesy of Tom Keck.)

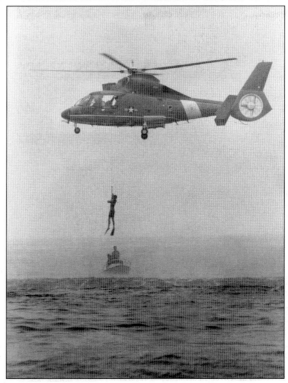

Lifeguard Knox Harris enjoyed his retirement. Fifty years after he began his lifeguard career, Harris, like many of his old lifeguard brethren, had less hair and carried more weight. He is quoted in his obituary as saying "I wouldn't trade the lifeguarding days for all the money in the world." Harris died of a heart attack in April 1994 at age 71. (Courtesy of Tom Keck.)

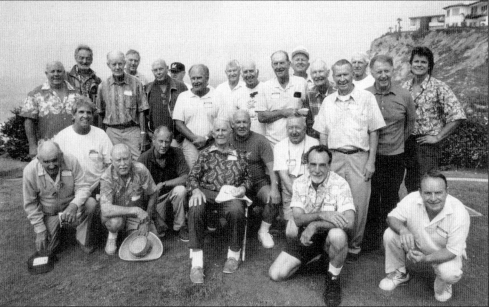

Many of the old San Diego city and county lifeguards reconvened for a reunion at the Solana Beach station in the early 1990s. Pictured here are, from left to right, the following: (first row) Emil Sigler, unidentified, Bill Rumsey, Jim Lathers, and Richard Lathers; (second row) Tom Keck, unidentified, Mike Considine, and unidentified; (third row) Knox Harris, John Brannon, John Elwell, Pat Kahlow, three unidentified people, Red Shade, and Peter Zovanyi; (fourth row) Dempsey Holder, Jim Voit, two unidentified people, Kimball Daun, and John Bowen. (Courtesy of Tom Keck.)

Seven

ENCINITAS

The city of Encinitas incorporated in 1986, comprised of five communities: Old Encinitas, New Encinitas, Olivenhain, Cardiff, and Leucadia. Lifeguard services were provided by the San Diego County Lifeguard Service beginning in 1941. The California State Park Lifeguard Service took over Cardiff State Beach and the San Elijo Campgrounds in the late 1950s. From 1986 until 1991, Solana Beach provided lifeguard services to the Encinitas areas not covered by the state parks lifeguards. On July 1, 1991, Encinitas joined Del Mar and Solana Beach as yet another small municipality operating its own lifeguard service.

The main lifeguard headquarters in Encinitas were located at Moonlight Beach. Larry Giles, 23 years old, served as supervising lifeguard. Giles had three senior staff members: Craig Miller (the current Solana Beach lifeguard captain), Ron Ayres, and Mark Athanacio. Giles also hired 11 rookie lifeguards, and the city provided two new four-wheel-drive pickup trucks. At the time, the service did not have a boat or a personal watercraft for offshore operations. If needed, the plan was to cooperate with Solana Beach lifeguards and request their rescue boat or, in extreme cases, contact the Coast Guard. The City of Encinitas Lifeguard Service is now under the city's fire department and is no longer deficient in watercraft.

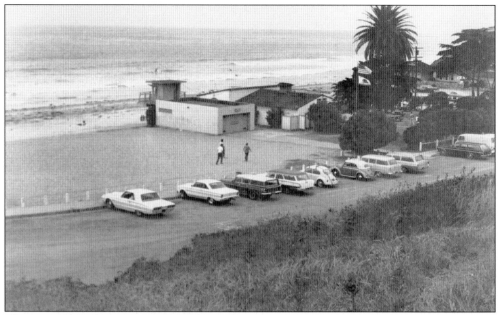

The cars of beach patrons are seen here along the frontage road that runs north and south past the San Diego County Lifeguard Service's tower at Moonlight Beach in Encinitas. For the curious, the cars are, from left to right, a 1964 Ford Thunderbird, a 1963 Ford Falcon Futura, a 1959 Rambler 6 station wagon, a 1958 Chevy Brookwood station wagon, a 1964 Volkswagen Beetle, a late-1950s Volkswagen Beetle, a 1955 Chevy wagon, a 1961 or 1962 Pontiac Bonneville station wagon, and a 1964 Ford Econoline panel van. In the upper right corner, behind the trees, are a 1966 Chevy Impala and a 1957 Ford Fairlane 500 two-door sedan. (Courtesy of California State Lifeguard Service.)

Four ladies enjoy Moonlight Beach in September 1952. The county lifeguard tower is in the background. (Courtesy of City of Encinitas Lifeguard Service.)

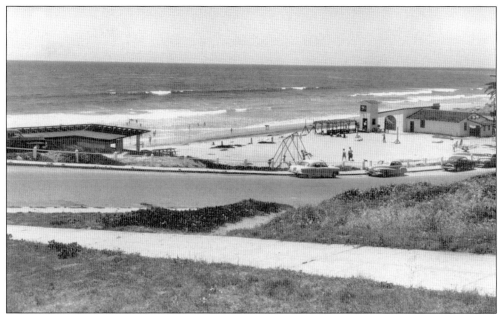

The waves off Moonlight Beach and the county lifeguard tower provide the setting for this June 10, 1952, beach scene. (Courtesy of City of Encinitas Lifeguard Service.)

Patrons at the north end of the beach enjoy the afternoon of August 3, 1951. A vendor in the building north of the lifeguard tower provided beach umbrellas, chairs, and snacks for beachgoers. (Courtesy of City of Encinitas Lifeguard Service.)

Just south of Moonlight Beach, county and state lifeguards respond to a drowning victim. The county lifeguard who has just arrived in the late-1970s Ford F-250 might be Pete Zovanyi. In the photograph above, the rescuing lifeguard can be seen with his rescue buoy still strapped over his shoulder while rescuers provide CPR to the victim. In the photograph below, the rescue tube has been removed, and firemen, paramedics, state lifeguards, and county lifeguards continue their efforts. (Courtesy of Tom Keck.)

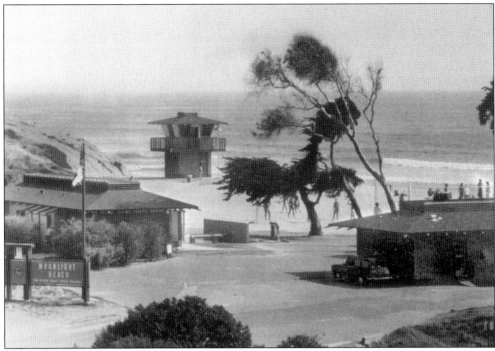

Moonlight Beach in Encinitas has been under the jurisdiction of the San Diego County Lifeguard Service, the California State Park Lifeguard Service, the City of Solana Beach Lifeguard Service, and now the City of Encinitas Lifeguard Service. The sign at the bottom left of the photograph announces that the beach was run at the time by "San Diego Coast Beaches." Though the beach has been protected by different agencies throughout the years, the goal of providing a safe recreation environment for beachgoers has always been the same. (Courtesy of City of Encinitas Lifeguard Service.)

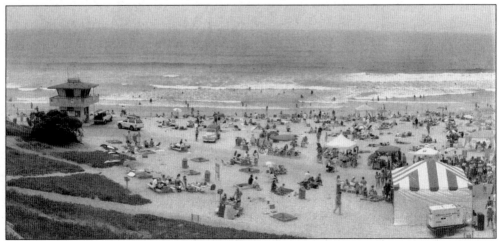

This is Moonlight Beach on June 21, 1999. The beach attire has changed since the days of the county lifeguard service and the old county tower is gone, but Moonlight Beach is still a favorite destination. (Courtesy of City of Encinitas Lifeguard Service.)

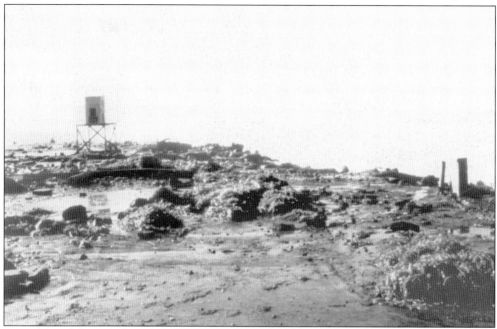

The 1983 El Niño year provided spectacular surf and equally spectacular damage. California State Parks Lifeguard Tower No. 5 is seen among the coast highway rubble. (Courtesy of City of Encinitas Lifeguard Service.)

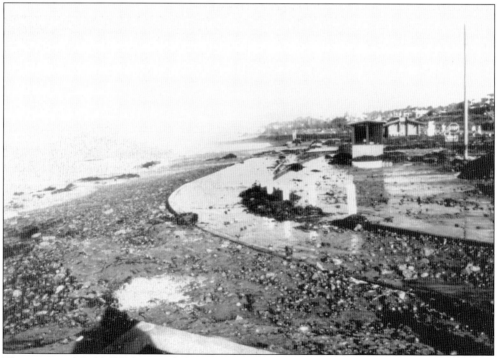

This image of Cardiff State Beach, located in Cardiff just south of the San Elijo Campground, shows the effects of the El Niño–generated storm in the winter of 1983. (Courtesy of City of Encinitas Lifeguard Service.)

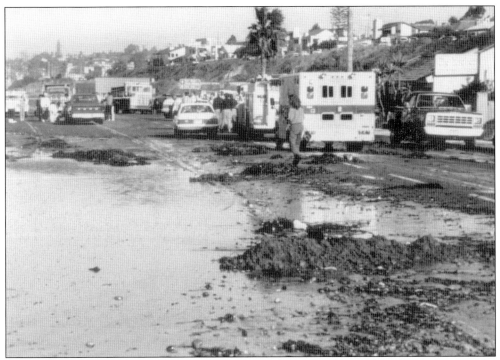

Water and ocean debris closed the coast highway and inundated a number of restaurants in the area. (Courtesy of City of Encinitas Lifeguard Service.)

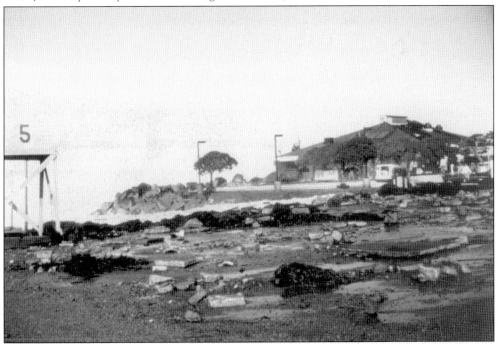

In this photograph, with tower 5 in the foreground and the Chart House Restaurant in the background, it is easy to see the rocks and debris tossed ashore during the storm. (Courtesy of City of Encinitas Lifeguard Service.)

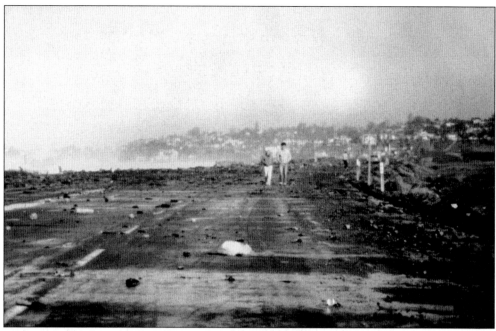

Here the often clogged and crowded coast highway is closed to vehicle traffic, providing a peaceful post-storm hike for this couple. (Courtesy of City of Encinitas Lifeguard Service.)

The original staff of the City of Encinitas Lifeguard Service is pictured here in 1991, their first summer. The lifeguards are kneeling, and behind them is the staff of the parks and recreation department. The lifeguard service was originally placed under the control of the parks and recreation department, but now, like many of the city lifeguard agencies, it falls under the city fire department. (Courtesy of City of Encinitas Lifeguard Service.)

Visitors to the beach and beach parks provide constant opportunities for lifeguards to practice their trade, and often it is their choices that lead them into trouble. Lifeguards readily respond to their distress, performing rescues and providing first aid or any other service required. Here a visitor riding his skateboard is about to give lifeguards an opportunity to hone their first-aid skills. (Courtesy of City of Encinitas Lifeguard Service.)

Larry Giles (left) and Chris Gage drag a near-drowning victim from the waters of Moonlight Beach in 1996. (Courtesy of City of Encinitas Lifeguard Service.)

A cliff below Neptune Avenue collapsed on January 15, 2000. Rescue workers and Encinitas lifeguards search the rubble on the beach below. Sadly the boulders crushed a young wife who was watching her husband surf. (Courtesy of City of Encinitas Lifeguard Service.)

One thing lifeguards know for certain is the power of the waves. The constant pounding of relatively small, seemingly insignificant waves can be as destructive as the big waves., In this 1999 photograph, those small waves have reduced the vessel *Andromeda* to scraps. (Courtesy of City of Encinitas Lifeguard Service.)

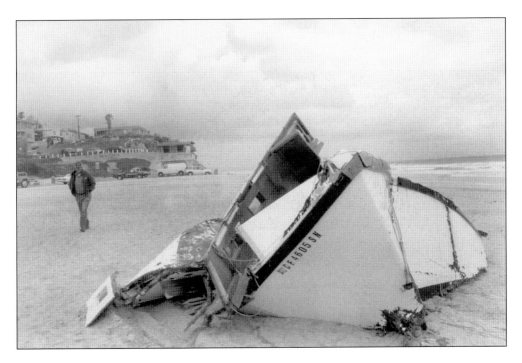

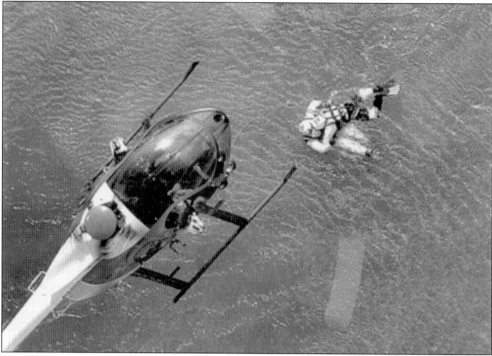

Modern lifeguards take full advantage of the rescue potential that a helicopter provides. Here two lifeguards train with the sheriff's ASTREA helicopter. The pilots and lifeguards are practicing plucking a lifeguard and his victim from the water. (Courtesy of City of Encinitas Lifeguard Service.)

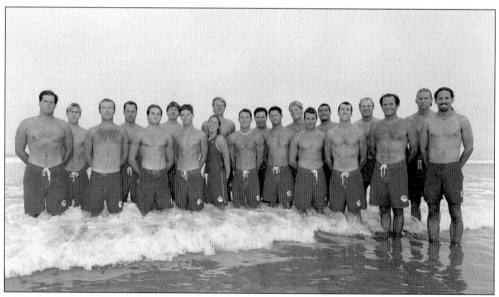

Encinitas lifeguards pose for their staff photograph in the environment where they do the most work: the ocean. Pictured fourth from left is Capt. Larry Giles, and pictured 12th from left is Craig Miller, the captain of the Solana Beach lifeguards. (Courtesy of City of Encinitas Lifeguard Service.)

Eight

OCEANSIDE

Like the City of San Diego Lifeguard Service and the San Diego County Lifeguard Service, the City of Oceanside Lifeguard Service was born of tragedy. On Sunday, August 21, 1921, Lt. George F. Stockton, a survivor of the torpedoed World War I ship USS *San Diego*, went into the surf just after lunch. In an event that is all too familiar along the ocean shoreline, a strong rip current pulled Stockton beyond the end of the pier. He struggled in the current and surf while rescuers tried to carry a life buoy out to him. The large surf rebuffed the would-be rescuers. Others tried to launch the old surf dory provided by the bathhouse, but the boat, long in disrepair, could barely float; it leaked, its wood was rotted, and its oar locks were missing. Inventive rescuers fashioned oarlocks out of rope and paddled the derelict boat out to Stockton, but he had disappeared below the waves. His body came in with the tide a week later, on Saturday, August 27, 1921.

A grand jury hearing was held after the tragedy. The *Oceanside Blade Tribune* reported the jury's statement: "We, the jury, further find that the life of George Francis Stockton could have been saved had there been proper life-saving apparatus on the beach, and we further find that the life-boat was not seaworthy and was full of cracks. There were no ropes present and the life preservers were water-logged." On July 2, 1925, the city trustees employed a lifeguard for July 4 and 5. In 1926, the City of Oceanside Lifeguard Service began providing lifesaving services to the public.

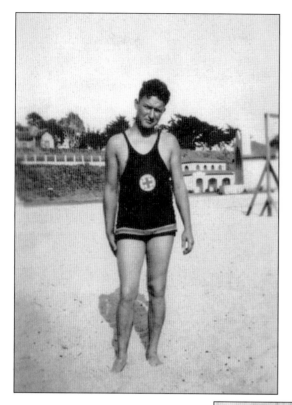

Oceanside lifeguard Theodore C. Johnson, pictured here, was the first known lifeguard for the city. Two of Johnson's great-grandsons are lifeguards with the service today. (Courtesy of City of Oceanside Lifeguard Service.)

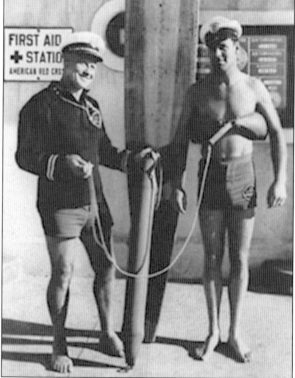

Two lifeguards demonstrate the flexible rescue tube. Unlike the can buoy, this rescue device may be strapped around the victim. Its advantage is the ability to tow in an unconscious victim. Its disadvantage is that early models required air and often leaked. (Courtesy of City of Oceanside Lifeguard Service.)

Byron Jessop poses atop an old wooden paddleboard. Notice the flat sides—no rounded rails here. The edges of the board caused bruising for those who sat astride it for too long. (Courtesy of City of Oceanside Lifeguard Service.)

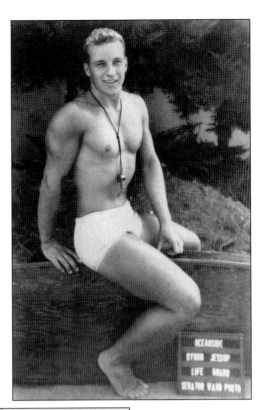

A slightly older Byron is seen here with a newer model board. The old paddleboard is in the background, resting against the lifeguard tower. (Courtesy of City of Oceanside Lifeguard Service.)

Lifeguard Doug Tico poses with the same board. Tico worked with the City of Oceanside Lifeguard Service from 1944 until 1950. He was the first instructor for the service's fledgling junior lifeguard program. (Courtesy of City of Oceanside Lifeguard Service.)

The 1950 lifeguard staff poses with the new junior lifeguards. The third kid from the left is Phil Edwards, who grew up to be quite a surfer. (Courtesy of City of Oceanside Lifeguard Service.)

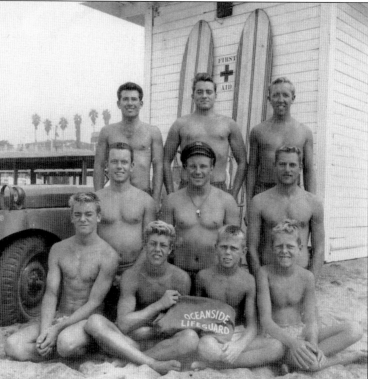

This is the lifeguard staff in 1950. Byron Jessup is at the bottom right. The June 13, 1950, *Blade Tribune* credits the crew with five rescues during the weekend. On Saturday, Tico had a double rescue, and Jessup pulled someone in later in the day. On Sunday, John Oakley pulled in one person, and Joe Trotter and Byron Jessup teamed up for yet another rescue. (Courtesy of City of Oceanside Lifeguard Service.)

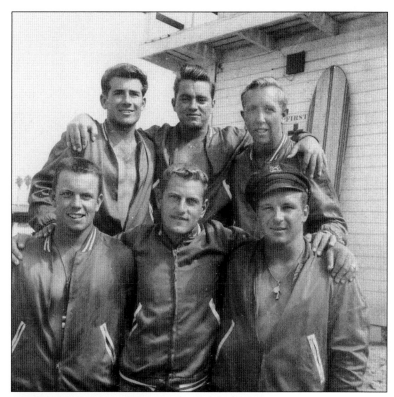

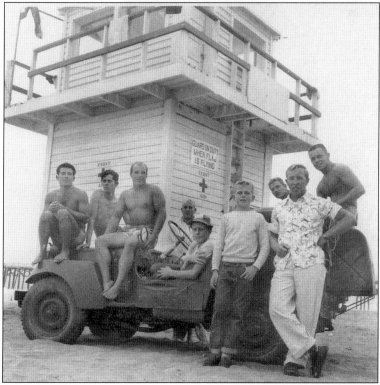

The lifeguards and some of the young junior guards lounge on a military surplus Jeep. The Willys Jeeps found service up and down the coast. The ladder at the back of the tower was for non-emergency access. There was a pole at the left side of the tower that lifeguards could slide down in an emergency. (Courtesy of City of Oceanside Lifeguard Service)

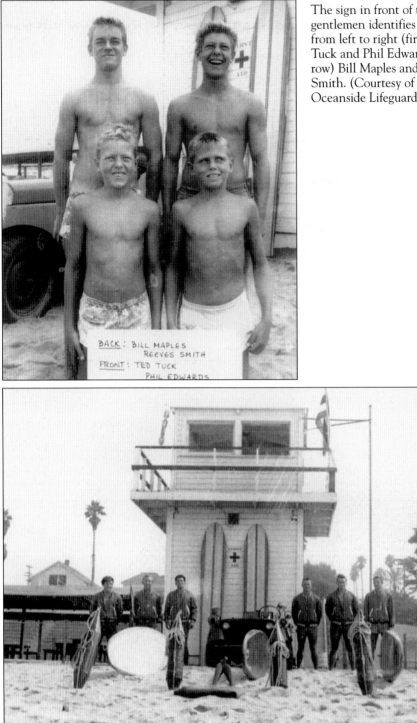

The sign in front of the young gentlemen identifies them as, from left to right (first row) Ted Tuck and Phil Edwards; (second row) Bill Maples and Reeves Smith. (Courtesy of City of Oceanside Lifeguard Service.)

The members of the 1950 crew proudly show off their equipment: four metal can buoys, three paddleboards, two surfboards, and a Willys surplus Jeep. (Courtesy of City of Oceanside Lifeguard Service.)

No matter what the year or the location of the beach, lifeguards all have to run quickly to the water, deploy their rescue tube, slip on their fins, and perform the rescue. The basics of the job have not changed. (Courtesy of City of Oceanside Lifeguard Service.)

Sometimes the rescue or recovery requires a slower, more methodical approach to the water. The crowd on the pier seems interested regardless of whether the entry is fast or slow. (Courtesy of City of Oceanside Lifeguard Service.)

One of the more dramatic methods of water entry for lifeguards working the pier is the pier jump. All Oceanside lifeguards must be able to perform this technique safely. (Courtesy of City of Oceanside Lifeguard Service.)

Lifeguards perform a cervical spine stabilization on a patient who, unlike the lifeguards, did not achieve a successful pier jump. (Courtesy of City of Oceanside Lifeguard Service.)

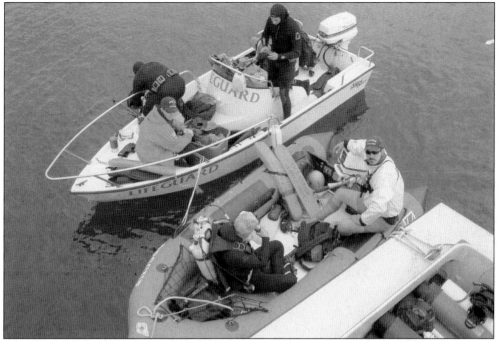

These two boats are being used to deploy divers for a search and recovery operation. The IRB belongs to Oceanside, and the other vessel is from City of Solana Beach Lifeguard Service. (Courtesy of City of Oceanside Lifeguard Service.)

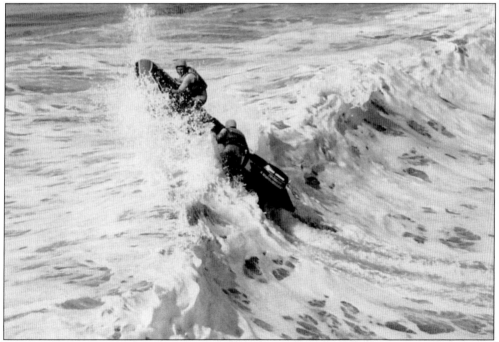

One advantage of the IRB is the ability to launch the vessel from the beach. It is up to the operator and his deckhand to punch through the surf. Once over the crest, the man at the bow shifts his weight forward to help execute the maneuver. (Courtesy of City of Oceanside Lifeguard Service.)

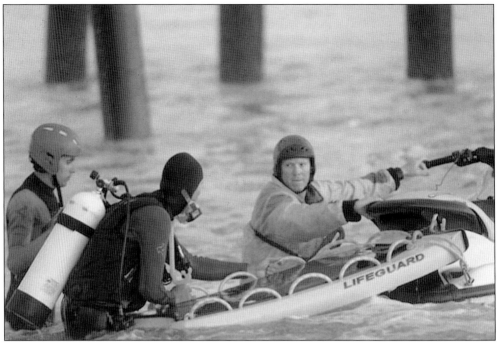

Jet skis with rescue sleds are also used to deploy lifeguards and make rescues. The vessels are supplanting the IRB as the rescue craft of choice, although what is gained in maneuverability is lost in deck space for carrying gear. (Courtesy of City of Oceanside Lifeguard Service.)

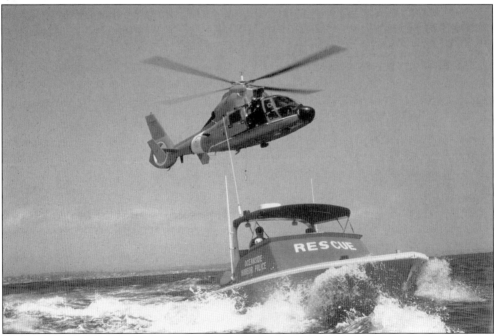

The Oceanside lifeguard service works closely with the Oceanside Harbor Police. Above the boat hovers a Coast Guard helicopter, another asset that can be utilized in rescue operations. (Courtesy of City of Oceanside Lifeguard Service.)

Nine

SDR ALERT

The official title of the organization known as SDR ALERT is a mouthful: San Diego Regional Aquatic Lifesaving Emergency Regional Taskforce. The formation of the group completes a nearly 100-year journey in aquatic lifesaving along San Diego County's coastline. The task force is made up of representatives from all of the lifeguard agencies in the county, along with sheriffs, harbor police, and the Coast Guard.

SDR ALERT can trace its formation to the Regional Lifeguard Academy. Formed in 1997, the academy allowed the various agencies in San Diego County to pool their resources and provided one regional location for training all prospective lifeguards. The candidates who passed the 80-hour training course were eligible to apply to any of the lifeguard agencies in the county except for the California State Parks Lifeguard Service, which has its own statewide academy at Huntington Beach, and the City of Del Mar Lifeguard Service, which still trains its own staff. From this regional academy, the seeds of cooperation were sown.

It was yet another tragedy that prompted the creation of SDR ALERT. On August 25, 2003, helicopter pilot Sean O'Kane was killed when he crashed in heavy fog off Moonlight Beach. The Encinitas lifeguards were understaffed and under-equipped for such an operation, and they called for aid from the surrounding agencies. After the recovery mission was completed, the heads of the various agencies formed SDR ALERT to continue developing professional relationships and the ability to pool resources in mass-rescue and mass-casualty aquatic events. The task force's goal is to provide an efficient interagency response to any major aquatic incident along the coastline of San Diego County.

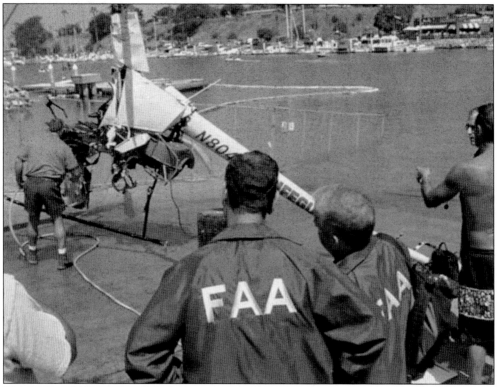

Pictured are the remains of the helicopter flown by Sean O'Kane. The wreckage was found in 65 feet of water on September 3, 2003. O'Kane's body was still strapped into the pilot's seat. (Courtesy of SDR ALERT.)

Members of the various agencies comprising SDR ALERT pose for a group photograph at their first task force meeting. In the front row, third from the left, is Rick Wurts of the City of San Diego Lifeguard Service. To the right of Wurts are Larry Giles of the City of Encinitas Lifeguard Service and Doug Samp of the U.S. Coast Guard. These three men made up the original executive board of the task force. (Courtesy of SDR ALERT.)

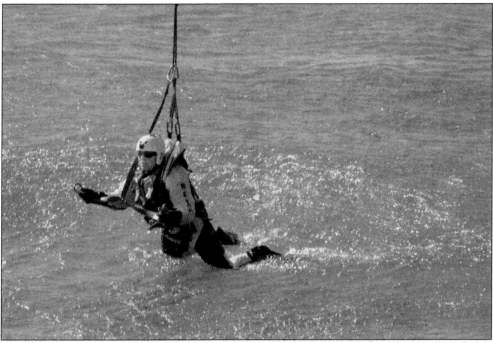

SDR ALERT tries to create opportunities for interagency training. Lifeguards work with sheriffs, search and rescue teams, and helicopters. This lifeguard is preparing to secure a victim during one of the training exercises. (Courtesy of SDR ALERT.)

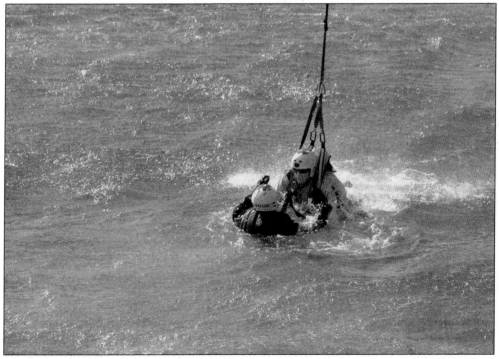

The helicopter pilot maneuvers the lifeguard into position, and the rescuer applies a harness to the victim before being lifted out of the water and to safety. (Courtesy of SDR ALERT.)

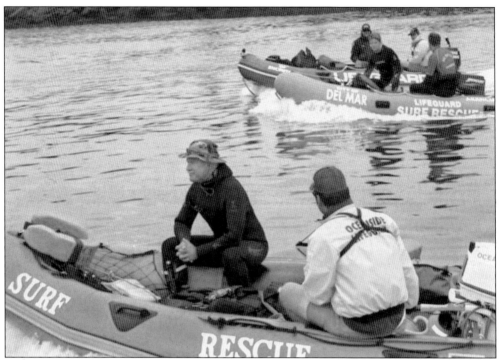

Lifeguards from Encinitas, Del Mar, and Oceanside, along with an Oceanside Harbor Police officer, deploy on a body-recovery exercise. (Courtesy of SDR ALERT.)

San Diego lifeguards, Encinitas lifeguards, and state parks lifeguards, along with San Diego firefighters, are briefed before going in on a collapsed section of cliff at Black's Beach. (Courtesy of SDR ALERT.)

Capt. Rick Wurts of the City of San Diego Lifeguard Service, who is also the president of SDR ALERT, briefs the gathered lifeguards before a May 2005 Mass Rescue Operation (MRO) drill at Mission Bay. (Courtesy of SDR ALERT.)

Members from all of the lifeguard agencies in San Diego County take notes as they prepare for their various roles in the MRO. (Courtesy of SDR ALERT.)

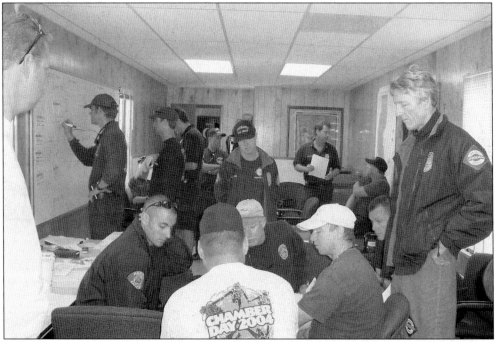

Inside the "ready room," lifeguards discuss the operation. Coronado lifeguard captain Sean Carey (at the dry-erase board) goes over the finer points of the recovery with some of his crew members. (Courtesy of SDR ALERT.)

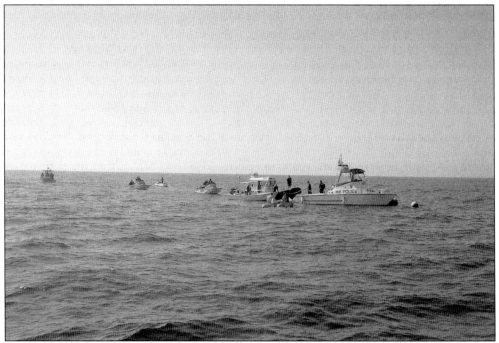

Lifeguards representing agencies from throughout San Diego County work their search pattern. Jet skis, IRBs, and various types of patrol boats work in unison to perform the rescue and recovery operation. (Courtesy of SDR ALERT.)

Born in Green Bay, Wisconsin, Michael Martino came to San Diego with his family in 1982. He graduated from Mount Carmel High School and went on to earn his bachelor's degree in literature and writing at the University of California, San Diego. He also earned minors in philosophy and mathematics. He earned a teaching credential in the early 1990s and had a short-lived career as a high-school English teacher. All through college, Martino worked as a seasonal state park lifeguard in the north county of San Diego. He then transferred to work as a lifeguard along the Sonoma coast near the town of Jenner. After four years along the Sonoma County coast, Martino went to the California State Parks Peace Officer Academy, where he became a state park ranger. Over the next six years, he worked at state parks from Carlsbad to Silver Strand, then transferred to the San Luis Reservoir as a lifeguard. While at the San Luis Reservoir, Martino went to California State University, Stanislaus, and earned a master's degree in rhetoric and the teaching of writing. In June 2004, he transferred back to the San Diego coast and is the lifeguard supervisor at Silver Strand State Beach. He is the author of a short story collection entitled *A Baker's Dozen of the LawGiver*. Martino plans to continue his research into San Diego County lifeguard history and anticipates writing a comprehensive history of the San Diego County coastline and the lifeguards who watch its shores. (Courtesy of Det. Doug Ravaglioli, Turlock Police Department.)

REFERENCES

Adams, Freda Elliot. *History of Imperial Beach*. Imperial Beach, CA: Imperial Beach Garden Club, 1976.

Aguirre, David. *Waterman's Eye: Emil Sigler—Surfing San Diego to San Onofre 1928–1940*. San Diego: Tabler and Wood, 2007.

Baxley, Robert C. *The Lifeguards*. El Cajon, CA: Whitmar Electronic Press, 1998.

Castanien, Pliny. *To Protect and Serve: A History of the San Diego Police Department and Its Chiefs*. San Diego: San Diego Historical Society, 1993.

Feuling, Jim. *Early California Surfriders*. Ventura, CA: Pacific Publishing, 1995.

Haskett, Wendy. *Backward Glances: Vol. 1*. Haverford, PA: Infinity Publishing, 2002.

Held, Ruth Varney. *Beach Town: Early Days in Ocean Beach*. San Diego: self-published, 1975.

King, Irving H. *The Coast Guard Expands, 1865–1915: New Roles, New Frontiers*. Annapolis: Naval Institute Press, 1996.

Noble, Dennis L. *That Others Might Live: The U.S. Life-Saving Service, 1878–1915*. Annapolis: Naval Institute Press, 1994.

Oceanside Blade Tribune. Oceanside, CA: 1921, 1924, 1925.

San Diego Evening Tribune. San Diego: 1918.

San Diego Sun. San Diego: 1918.

San Diego Union. San Diego: 1918, 1941.

Shanks, Ralph; Wick York; and Lisa Woo Shanks. *The U.S. Life-Saving Service: Heroes, Rescues, and Architecture of the Early Coast Guard*. Petaluma, CA: Castaño Books, 1996.

Verge, Arthur C. "George Freeth: King of the Surfers and California's Forgotten Hero." *California History Magazine*, summer/fall 2001.

———. *Los Angeles County Lifeguards*. Charleston, SC: Arcadia Publishing, 2005.

INDEX

ACROSS AMERICA, PEOPLE ARE DISCOVERING SOMETHING WONDERFUL. *THEIR HERITAGE.*

Arcadia Publishing is the leading local history publisher in the United States. With more than 4,000 titles in print and hundreds of new titles released every year, Arcadia has extensive specialized experience chronicling the history of communities and celebrating America's hidden stories, bringing to life the people, places, and events from the past. To discover the history of other communities across the nation, please visit:

www.arcadiapublishing.com

Customized search tools allow you to find regional history books about the town where you grew up, the cities where your friends and family live, the town where your parents met, or even that retirement spot you've been dreaming about.

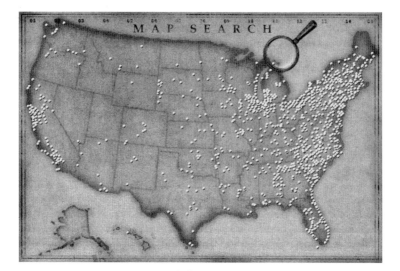